Claude Monet

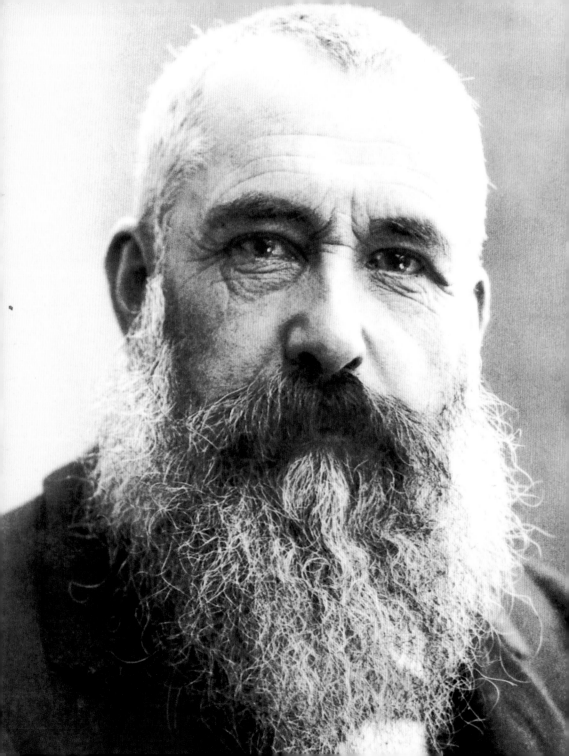

Claude Monet

Life and Work

Birgit Zeidler

KÖNEMANN

Childhood and Youth
Page 6

Training
Page 12

1840	1850	1860
1890	1900	

Travels and Retreat
Page 54

The Law of the Series
Page 66

Restless Search
Page 24

The Impressionist
Page38

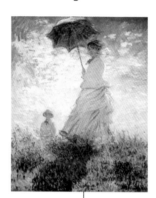

1870	1875	1880
1920	1926	

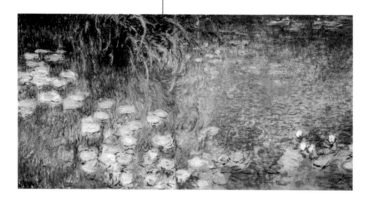

Water Lilies
Page 78

Childhood and youth

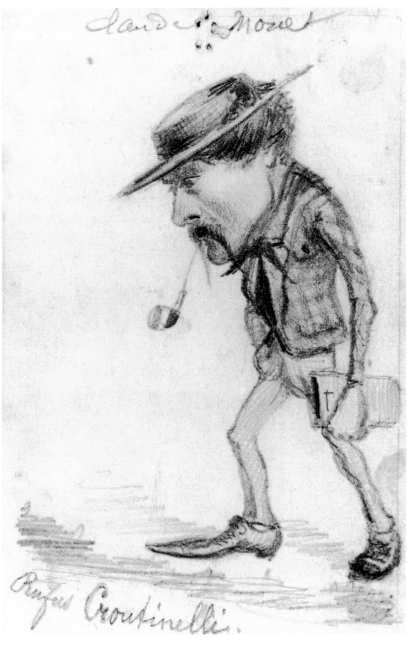

Oscar-Claude Monet revealed his drawing skills at school. During dreary lessons at the *lycée* in Le Havre, the bored schoolboy drew caricatures of his teachers. Soon he was so adept that he found ready purchasers among his classmates. Claude followed up these successes out of school and earned his first money with satirical drawings. As caricature was in fashion and Monet used a proven, popular approach, the 17-year-old cartoonist rapidly established an eager group of regular customers. He was even allowed to exhibit his drawings in the window of a frame-maker's shop. In such favorable circumstances, the youthful entrepreneur proceeded by leaps and bounds to become a caricaturist of city-wide repute.

Despite this early success, Claude's father showed little appreciation of his son's activities. Monet found a more receptive audience in his childless aunt, who devoted greater attention to her nephew after the death of his mother.

Karl Marx ca. 1848.

Monet at the age of 18 (1858)

1840 Napoleon III escapes to England.

1848 Karl Marx and Friedrich Engels publish *The Communist Manifesto.*

February Revolution in Paris. Second Republic under Louis Napoleon.

1850 Beginning of industrialization.

1840 Oscar-Claude Monet born in Paris on November 14 as the second son of Claude-Adolphe Monet and Louise-Justine Aubrée.

1845 The family moves to Le Havre, where the father works for his brother-in-law's groceries business.

1851 Monet starts school in Le Havre. His drawing teacher is Jacques-François Ochard, a pupil of Jacques-Louis David.

1856/57 Monet exhibits his caricatures in Gravier's shop in Le Havre. Becomes acquainted with Eugène Boudin.

Opposite:
Rufus Croutinelli, ca. 1859
Black crayon on paper
13 x 8.4 cm
Art Institute, Chicago

Childhood and Family

Oscar-Claude came into the world in Paris on November 14, 1840 as the second son of Louise-Justine and Claude-Adolphe Monet. The young family lived at no. 45, rue Laffite in simple circumstances, like most of the residents of this district around Montmartre. The locality, indeed the very street, would later become a desirable address for the best-known art dealers in France, but for the time being the shopkeepers, workers, ordinary office workers, and artists had it to themselves.

Monet's parents apparently ran a small shop, but this was so unsuccessful that in 1845 the family left Paris and resettled in Le Havre in Normandy. Claude's father found new employment in the flourishing

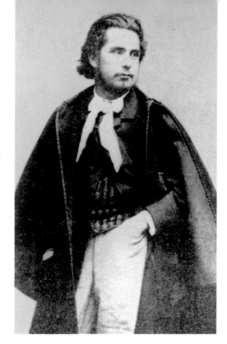

groceries business run by his brother-in-law, Jacques Lecadre. Henceforth, things would go better for the Monets, and Claude and his brother Léon thus grew up in relatively well-off and secure circumstances. Indeed, their musical mother even organized balls and concerts at regular intervals. When Jacques Lecadre died in 1858, Adolphe Monet took over his brother-in-law's business and took charge of the welfare of the whole family.

After the premature death of his mother in 1857, young Oscar-Claude developed a closer relationship with his aunt, Marie-Jeanne Lecadre, an amateur painter. His relationship with his father, whose interests were entirely business-oriented and whose wish was that his sons have a bourgeois education and career, were generally strained.

Oscar-Claude Monet was born at no. 45, rue Lafitte, near Montmartre, photo ca. 1850.

Claude went to the city *lycée* in Le Havre, much to his chagrin, as he was not naturally academic and became bored. During lessons, he preferred to draw garlands in his exercise books or toss off caricatures of his teachers. These and other sketches in his first school record books demonstrate the precocious drawing abilities of the young Monet, despite the subjects coming largely from his textbooks. At any rate, even at this time Monet's talent must have been encouraged, because the school was fortunate to have an art master of some standing in François Ochard, a pupil of Jacques-Louis David, who was a celebrated history painter in his day.

The "portraits" of his teachers soon became much prized among his fellow pupils, bringing Monet his first recognition. By the time he finally left school between 1855 and 1857, presumably without matriculating, the 17-year-old Monet had already earned his first money with caricatures of this kind.

View of the Bassin du Commerce at Le Havre, photo around the turn of the century

The city on the coast of Normandy is among the most important ports in France. Overseas trade and the stationing of some naval units there brought Le Havre prosperity and encouraged cultural life.

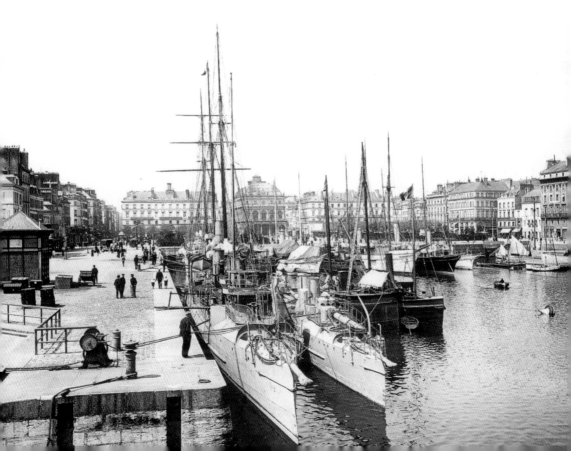

The Young Caricaturist

Word of Monet's wicked eye for the people around him soon got about in Le Havre. This happy circumstance was due not least to the fact that in 1856/57 he was allowed to exhibit his drawings in window of Gravier's artist supplies and frame shop in the Rue de Paris. Little clusters of curious passers-by would constantly form in front of the shop window to look at the latest caricatures and make comments in amusement. Soon, Monet was caricaturing not just well-known faces from politics and culture familiar to all the world from the daily press, but was getting commissions from his friends.

Though caricature did not count as an independent artistic genre, due to the new technique of steel engraving it had since 1830 become an everyday and highly popular feature in the daily press. Drawings by caricaturists such as Carjat, Hadol, and Nadar (who was moreover a well-known photographer) were familiar to Monet as well, and in fact they demonstrably influenced his style. At any rate, his drawings were quite clearly to the public's taste, as the young artist had soon earned a proud 2,000 francs with them – commercial success and early fame that the ambitious young entrepreneur noted with satisfaction as a first step in his career.

Mario Urchard, ca. 1859
Pencil on paper
31.8 x 24.6 cm
Art Institute, Chicago

This drawing of the writer Mario Urchard (1824–1893) was done from a caricature by Carjat. While he was still mainly practising his skills as a caricaturist, Monet decided to adopt the attitude of an artist, which was to mark his later works as well: in this as in most of his other drawings, he focused on the character of the subject by concentrating on just a few elements, which he enlarged out of all proportion. However, in contrast to many of his colleagues, his exaggerations were never sarcastic or malicious but instead intended in the most part to make identifying individual characteristics quick and comprehensible. As an artist, his attitude was more inclined toward description than comment – an approach that later was to apply to Impressionist art as a whole.

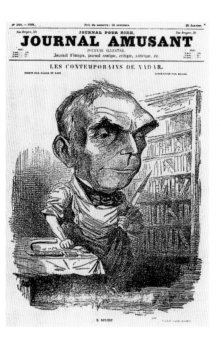

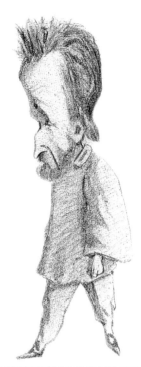

Théodore Pelloquet, 1858/59
Black crayon on brown paper
Musée Marmottan, Paris

Monet encountered journalist Pelloquet from 1859 at his favorite haunt, the Brasserie des Martyrs. During his first stay in the metropolis, Monet continued to live by selling his caricatures. Only a few small-scale sheets have survived, to some extent presumably because his first signature was "O. Monet."

Title page of the *Journal amusant*, with a caricature by Nadar, 1859
Lithograph by Édouard Riou

Nadar, who had made a name as both a photographer and caricaturist, turns the famous Parisian dramatist and librettist Eugène Scribe into a butcher, shown chopping up his dramatic material into the usual five acts, as if it were a sausage.

Petit Panthéon Théâtral, ca. 1859
Pencil and gouache on paper
34 x 17 cm
Musée Marmottan, Paris

Monet presumably did this caricature of famous Parisian actors, including Grassot (1800–1860) and Leclère (ca. 1800–1861), from newspaper illustrations. Stimulated by caricatures by Nadar, Hadol, and Carjat, Monet used the standard format of an overlarge, distorted head on an over-shortened body.

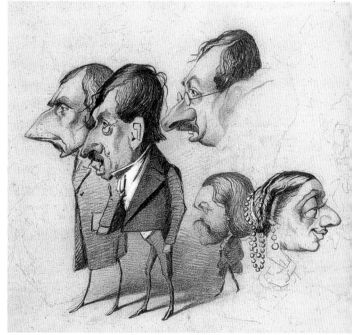

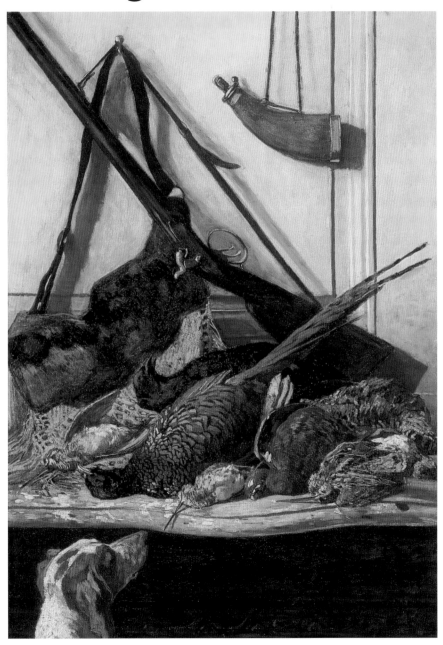

Initially, Monet had no precise idea what he wanted to be. As business with the caricatures was running entirely to his satisfaction, he saw no reason to stop. Only when the artist Eugène Boudin introduced him to landscape painting in the summer of 1858 and he made oil sketches in the open air did the enthusiastic Monet decide to become a painter and go to Paris. However, the constricting teaching of the Parisian studios did not agree with him. He spent a lot of time in the Brasserie des Martyrs and continued to sell caricatures. Call-up for military service in 1861 therefore suited him very well. He was sent to Algeria, but serious illness brought his military service to a premature end. In 1862, he returned to Paris, and at Gleyre's celebrated studio he became acquainted with fellow pupils Alfred Sisley, Pierre-Auguste Renoir, and Frédéric Bazille. Regularly painting in the open air, the friends were gradually able to develop their techniques.

Civil war in the USA, 1861–1865

1857 First world economic crisis. Flaubert's novel *Madame Bovary* published.

1859 Darwin causes controversy with his theory of the origins of species.

1861 Abolition of serfdom in Russia. France becomes second largest industrial nation in the world after Britain.

Monet at 20 as a soldier

1857 Monet's mother dies.

1858 Monet's first oil painting exhibited in Le Havre.

1859 Goes to Paris and enrolls at Académie Suisse.

1861 Military service in Algeria (to 1862).

1862 Returns to Paris to continue his studies.

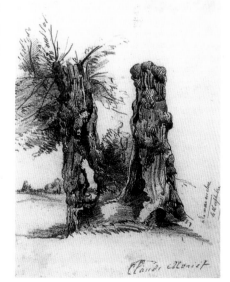

Opposite:
Hunting Trophies, 1862
Oil on canvas
104 x 75 cm
Musée d'Orsay, Paris

Right:
Study of a tree, 1857
Ink on paper
30 x 23 cm
Musée Eugène Boudin, Honfleur

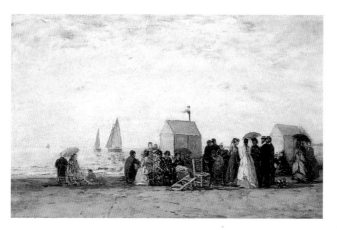

Learning in the Open Air

Inasmuch as Monet ever thought of an artistic career in his youth, that of a landscape painter must have seemed the least likely. This was due less to his successes as a caricaturist than the low prestige accorded at that time to landscape paintings and the consequent problem there was in selling them.

Monet's encounter with Boudin in 1856 was promoted by Gravier the frame-maker, who exhibited works by both and introduced them to each other. Although well known locally, Boudin had had little success as a landscape painter. Nonetheless, he advised Monet, 16 years his junior, not to limit himself to drawing caricatures but to try his hand at painting as well. After some hesitation, Claude finally decided to accompany Boudin on his trips to the Atlantic coast. As Monet himself said, at first he daubed away quite happily, but

Eugène Boudin
The Shore at Trouville, 1867
Oil on canvas
26 x 48 cm
Musée d'Orsay, Paris

In summer, well-off Parisians would parade the latest fashions at the Norman coastal resorts.

soon learnt to appreciate Boudin's quiet, simple landscape paintings, and let himself be guided by him. In small, tentative oil sketches he now practised looking accurately, and learnt how to translate the colors and shapes of nature into his pictures. Above all, his teacher taught him how to depict moods of light and cloud formations, as Boudin was interested in representing nature as such and had no interest in the nymphs and historical figures with which his contemporaries decked out their landscape paintings. (The public therefore took Boudin's seascapes of Normandy simply as copies of nature with no educational or prestige value.) Using a light color palette, he captured moods of light; he aimed particularly at atmospheric effect, setting the horizon low, and thus filling his canvases with high, wide skies. His pictures are, there-

Painter working in the open air (Eugène Boudin), 1856
Pencil on paper
30 x 22 cm
Musée Eugène Boudin, Honfleur

fore, distinguished by a brightness marked by a cool, silvery light. To enliven this atmosphere of calm, the artist introduces fugitive points of stress – patches of color on clothing or clouds deformed by wind.

An enthusiastic pupil, Monet translated Boudin's advice into his own pictures so convincingly that he was already exhibiting a painting (*View of Rouelles*) at the Le Havre art exhibition in 1858. His decision to become a painter was now final, regardless of his father's opposition. However, the latter perceived his son

was not to be moved, and applied for a public scholarship for his training. The scholarship application was turned down, on the grounds of his earlier, less serious drawing career – but, due to his savings from that same "career," Claude had already left for Paris without waiting for the answer.

View from Rouelles,
1858
Oil on canvas
46 x 65 cm
Marunama Art Park,
Japan

This first open-air landscape by Monet was exhibited in the same year in Le Havre with Boudin's works. It displays a rather cautious and conventional approach in the manner of his mentor.

Painting in the Open A

Above:
Jean-Baptiste-Camille Corot
The Ferryman, 1865
Oil on canvas
Galerie Daniel Malingue,
Paris

Below:
Charles-François Daubigny
The Lighters, 1865
Oil on canvas
38 x 67 cm
Musée du Louvre, Paris

When Boudin introduced young Monet to landscape painting, there was already a long tradition of *plein-air* or open-air painting, but it would only achieve special status from the 1870s, with the Impressionists.

Ever since Dutch painters of the sixteenth and seventeenth centuries turned their attention to their native landscape, open-air painting had become more important. The painters of the period did not of course set off for the country with all their painting gear but only produced sketches or ink studies outside, which later served as sources for their perfectly composed, usually large-format studio pictures.

From 1800, the English painters Constable and Turner introduced new, revolutionary elements into the studio pictures using open-air studies. They showed nature imbued with atmosphere and depicted at different times of the day. This new perception and representation of nature was to act as an example to Monet decades later.

In France a group of young painters including Jean-Baptiste-Camille Corot, Charles-Françoise Daubigny, Théodore Rousseau, and François Millet had, from about 1830, brought about an increase in the status of plein-air painting. Like the Dutch painters, they dedicated themselves to their native landscape. They retreated to Barbizon, on the edge of Fontainebleau forest south of Paris, and painted nature as they saw it in front of them, without the fashionable, historical or mythological glosses. The result was small-format landscape paintings in oil known as *paysages intimes* (intimate landscapes). Yet Corot and the artists who became known as the Barbizon School, never finished their paintings out of doors, although painting in the open became much easier after 1840 with the invention of transportable oil tubes. Monet's first teachers, Boudin and Jongkind (whom Monet met around 1862), likewise painted outside only to some extent.

Boudin declared it was quite legitimate to work up in the studio a still-fresh impression acquired on the spot outside. Both artists were masters in capturing transient appearances, as the painters' numerous seascapes demonstrate. These small, light water colors and oil paintings served the young Monet as models, particularly for recording fleeting moods of light.

Plein-air painting really came into its own with the Impressionists. In the 1870s, Monet and his fellow artists enjoyed their first great successes with works executed in the open air. The rapidly changing light and weather situation to which artists were exposed outside required speedy work. Due to impulsive brushwork and glowing colors, they were in a position to capture momentary moods. The automatic consequence of this spontaneous painting technique was that they summarized the shapes of nature and distanced themselves from detailed portrayal. The result was a new kind of landscape picture that was less a naturalistic document of a real place than a mood picture of a momentary situation. In the 1880s, more and more artists lost interest in plein-air painting, withdrawing to their studios as they sought new subject matter and techniques of composition. Even before that, many an

Eugène Boudin
The Beach at Trouville,
1867
Pencil and water color on paper, 32 x 48 cm
Privately owned

Impressionist open-air picture had been finished in the studio due to bad weather. In this respect, the continued equating of Impressionism and open-air painting even to this day is in considerable part a falsification of the facts.

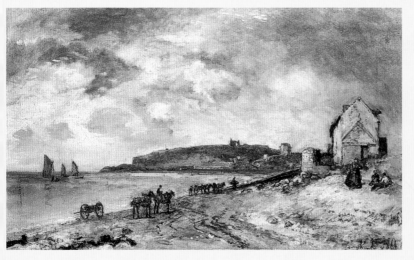

Johan Barthold Jongkind
Beach scene with horses,
ca. 1865
Oil on canvas
46 x 78 cm
Private ownership

How Do You Plan an Artistic Career?

They are a bunch striving after a new revolutionary art. Undeniably some of them have talent. If we accord their organization with the official hallmark of Salon quality, … it will mean the loss of great art and tradition.

Jury's explanation for rejecting Impressionist pictures at the Salon

Charles Gleyre
Evening (Lost Illusions),
ca. 1843
Oil on canvas
112 x 195 cm
Musée du Louvre, Paris

When Claude Monet arrived in Paris in May 1859, he could not simply embark on an artist's career. Standards had been laid down for the training and later recognition of artists that had to be addressed in the correct order. Thus, until the 1860s only such artists had a chance in the French art market as could present their works at the official art exhibition – the Salon, which took place every year or two. Acceptance for the Salon was decided by members of the Académie des Beaux-Arts, appointed for life by the state. A minimum pre-condition for acceptance was to have studied at the likewise state-run École des Beaux-Arts (art school), or at least one of the private studio schools controlled by it. To prepare for art school, most young candidates enrolled for private courses with recognized painters, such as distinguished Salon exhibitor Charles Gleyre or Benjamin-Constant, because a regulated training was important even for the entrance exam.

An artistic career following this model was supported by scholarships and several medals awarded by the state. An artist thus singled out was treated like a star; in fact his success was then basically pre-programmed. Artistic life in France had been state-supervised since

The Benjamin-Constant Studio, photo ca. 1860

Louis XIV. Art had long been recognized as a means of illustrating the power and doctrines of a ruler or increasing the prestige of a government. This is why art exhibitions had regularly taken place from 1673 under the control of the royal academy in the Salon Carré, a room at the Louvre (hence the terms Salon and Salon art). True, there was at the same time an "alternative" art show: Louis XIV had also set up a young artist's show that was organized in the open air, for example at the Pont Neuf, where even female artists could exhibit. (Women were otherwise admitted to academic training only from the 1880s.)

This rigid structure was enlivened from 1750 onwards by the development of art criticism. The main critic of that time was Denis Diderot, who guided public taste as Baudelaire or Zola were to do later.

From the mid-nineteenth century, the strict regimentation of the art scene began to loosen up. The first auction house opened in 1853 at the Hôtel

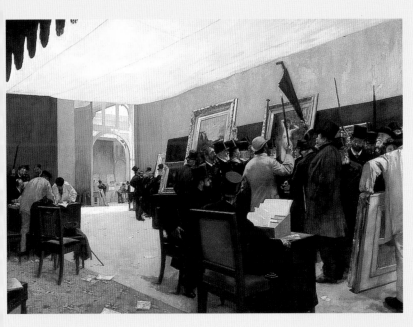

Henri Gervex
The Paintings Jury, Salon des Artistes Français, 1885
Oil on canvas
299 x 419 cm
Musée d'Orsay, Paris

Below:
Myrbach
The Graveyard of the Refusés
Illustration in *Paris Illustré* magazine, May 1885

Bottom:
Ernest Bichon
Exhibition at the Galerie Durand-Ruel, 1879
Etching

Drouot, and from the 1860s free art dealers became established, who organized both group and one-man shows for young artists. However, an artist who placed works with a gallery for a first showing had to consider that, although he might gain access to the art market that was just developing, it meant largely renouncing state recognition and the fame and greater commercial success it brought with it. For most artists, it was, therefore, worth trying to get into the state-run École and be accepted by the Salon, and then embark on the career of a history or portrait painter.

When over 3,000 works were turned down by the jury of the 1863 Salon and there were violent protests by the *refusés*, the Emperor Napoléon III organized a rival show called the *Salon des Refusés*. This alternative salon was continued from 1867 on a smaller scale by Courbet, Manet, and the first Impressionist shows, but really only reached maturity in 1886 as the Salon des Indépendants, where no jury was involved.

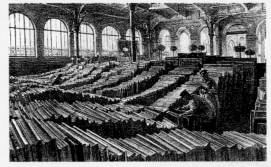

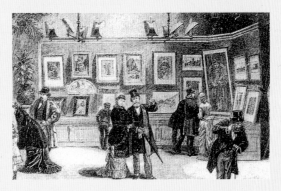

New Painter Friends

Monet arrived in Paris at the beginning of May 1859. His family had no objection to a state-recognized artist's career because the prospective earnings for a history or portrait painter were good. Bearing letters of recommendation and with two still-lifes tucked under his arm, Monet immediately called on established Salon painters, who were to help him identify the appropriate training studio. In the end, he enrolled at the Académie Suisse, a cheap studio that unfortunately did not enjoy the approval of the École des Beaux-Arts and therefore endangered Monet's artistic career. Indeed, his father immediately withdrew financial support. Monet now passed his time in the Brasserie des Martyrs, the favored haunt of bohemia. There he drew and continued to sell caricatures to replenish his dwindling savings. Vigorous discussions about current issues in art also featured, which sharpened Monet's eye for works of art and trends, and helped him to formulate his artistic position more clearly. His time at the Académie Suisse, during which he made friends with the young Camille Pissarro, was terminated by his call-up for military service in 1861.

However, in 1862 he returned to Paris after his aunt had bought him out of military service, and this time,

Camille Pissarro
Self-portrait, 1873
Oil on canvas
56 x 46.7 cm
Musée d'Orsay, Paris

This self-portrait shows Pissarro at the age of 43.

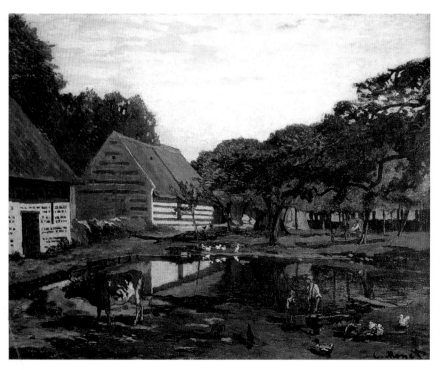

Farm in Normandy, 1863
Oil on canvas
65 x 80 cm
Musée d'Orsay

The painting shows a still very conventional landscape set in tones of brown. It is among the few pictures in which Monet shows people at work. In 1862, Monet met the Dutch landscape painter Jongkind in Le Havre. It was he who encouraged him in the development of a spontaneous technique. Monet soon showed progress in his painting technique, as the Honfleur picture a year later shows.

Pierre-Auguste Renoir, photo
ca. 1875

Rue de la Bavolle in Honfleur, 1864
Oil on canvas
58 x 63 cm
Städtische Kunsthalle, Mannheim

A second version of this picture exists, varying only in a few details – a circumstance that indicates Monet's serious study of pictorial composition.

Alfred Sisley, photo
ca. 1872

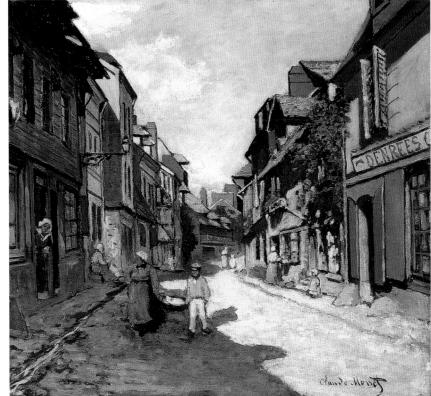

because of his family, enrolled at the famous studio of the painter Charles Gleyre. Three other art students began their studies there at the same time as Monet: Alfred Sisley, Pierre-Auguste Renoir, and Frédéric Bazille, who with Pissarro and Monet later formed the core of the Impressionists. In contrast to the discontented Monet, his fellow pupils were initially keen to learn. Their aim was to get a place at the École des Beaux-Arts, the art school. Sisley even intended to enter for the prestigious Prix de Rome, a five-year scholarship. Monet and his friends undertook painting excursions to the surroundings of Paris, now comfortably within reach by train. The young painters were increasingly unable to identify with Gleyre's traditional approach to art – that nature provided only study fodder that needed "ennobling" by idealization. In 1863 they left his studio, to paint in the open air of Fontainebleau forest.

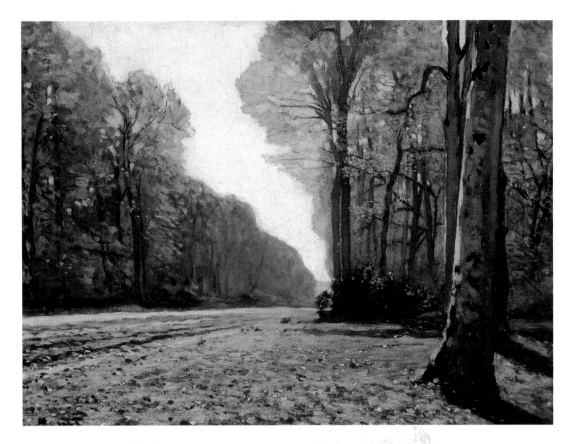

In Fontainebleau Forest

From 1863, Monet traveled several times, either alone or together with his friends, to Chailly, which is situated near Barbizon on the edge of Fontainebleau forest. The idea was that, like the Barbizon School, the group should paint in the open, directly from nature. Away from the hectic life of Paris, the art students practised reproducing the effects of light in pictures. Monet's pictures from this time testify to his extraor-dinary ability to choose the right section of landscape, to proportion all the pictorial features correctly and generate spatial depth. In his hand-ling of color, however, he was still groping his way forward. The result was that some pictures are still calm, in earthy tones, while other, show a cautious ambition for coloration and an interplay of green, yellow, and blue tones.

Enthused by what he had achieved, Monet prolonged his stay in Fontainebleau and decided to forego a visit to the annual Salon.

Road in Chailly, 1865
Oil on canvas
42 x 59 cm
Musée d'Orsay, Paris

There is a second version of this subject painted at a different season. Here, Monet was already trying to capture different atmospheric effects in one and the same subject.

The Bodmer Oak, 1865
Oil on canvas
96.2 x 129.2 cm
Metropolitan Museum of Art, New York

This picture dates from a further spell in Chailly in summer 1865. Despite the earthy ground tone, clear colors such as blue and green appear for the first time. The richly contrasting use of color produces a striking luminosity in this work. The tree was named after the painter Karl Bodmer, and was often used as a subject by the Barbizon painters.

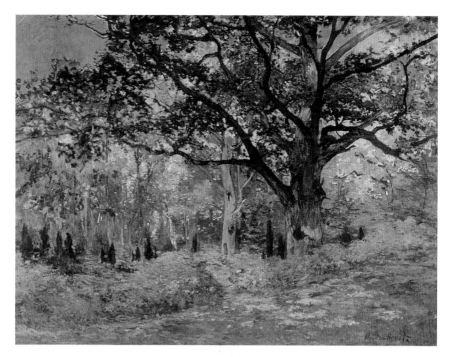

I found a thousand things that captivated me here which I simply could not resist. I've worked quite hard, and you will see that I looked more carefully than usual ... Now I must get back to my drawing.

Monet to the painter Armand Gautier, 1863

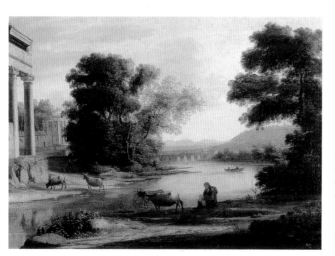

Claude Lorrain
Landscape with Shepherds, 1644
Oil on canvas
68 x 99 cm
Museo del Prado, Madrid

Lorrain's landscape is bathed in warm light, and its harmonious composition gives it a decidedly meditative character. The figures and themes of his pictures were of little interest to Lorrain, being subordinated to his ambition to create ideal pictorial worlds in which man and nature were in harmony. Representation of landscapes is thus of prime importance, but unlike the Impressionists, Lorrain painted not from nature but composed freely in accordance with his imagination.

Restless Search 1865–1871

The years preceding the Franco-Prussian War were a time of desperate financial hardship for Monet. He and his partner Camille frequently had to change address to escape creditors. The pictures he submitted to the Salon were repeatedly rejected, so that he began to fear for his career. In August 1867, Camille bore Monet's first son Jean, but Monet had to postpone his wedding, again because of a shortage of money. In 1870, shortly before war broke out, Monet finally married Camille and fled with her to London to escape conscription. After a very unproductive time in England – in which Monet nonetheless established important contacts with art dealers and other artists – the young family passed a happy summer in Zaandam in Holland, returning to Paris in November 1871 after the war had ended. Monet produced a few city views, but these were irrelevant to the work of the landscape painter.

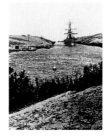

Suez Canal opened 1869

Monet ca. 1871

1865 Slavery abolished in the USA after the end of the Civil War.

1867 World exposition (Exposition universelle) in Paris.

1870 Franco-Prussian War (until 1871).

1871 The Paris Commune bloodily suppressed. Baron Haussmann commissioned to construct wide boulevards.

1865 Starts work on a giant canvas, the *Déjeuner sur l'Herbe*.

1866 Success at the Salon with *Camille in a Green Dress*.

1867 Short of money, he moves to his aunt's house at Sainte-Adresse. Camille gives birth to their son Jean.

1868 Awarded a silver medal at an exhibition in Le Havre. Moves to Etretat.

1870 Marries Camille. Seascapes in Trouville. Monet's close friend Bazille killed. To avoid conscription, Monet flees to London, where he meets the Parisian art dealer Paul Durand-Ruel.

1871 In London, he studies the work of Turner and Constable. Returns to France after a long stopover in Holland. The family settles in Argenteuil.

Opposite:
The Strollers (Bazille and Camille), 1865
Part study for *Déjeuner sur l'Herbe*
Oil on canvas, 93.5 x 96 cm
National Gallery of Art, Washington

Right:
Quai du Louvre, 1867
Oil on canvas, 65 x 92 cm
Gemeentemuseum, The Hague

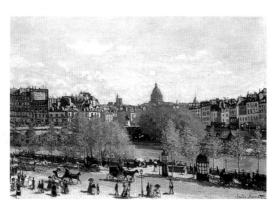

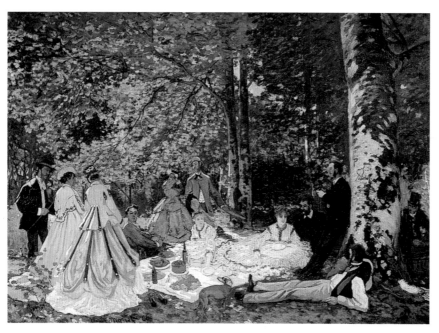

Le Déjeuner sur l'Herbe, 1865
Oil on canvas
130 x 181 cm
Pushkin Museum, Moscow

Both the title and content allude to Manet's work (opposite), but Monet strove for a more realistic setting: the light-drenched picture with its life-size figures, some captured in mid-movement, gives the impression of an authentic document of the moment. However, this studio picture followed weeks of studies in the open.

In Record Time

I no longer think of anything except my picture [Déjeuner sur l'Herbe] *and believe I shall go mad if it doesn't work.*

Monet to Bazille

The jury of the 1863 Salon rejected over 3,000 works, but following violent protests Napoléon III allowed another art show for those who had been rejected, called the Salon des Refusés. At this, Manet's picture *Déjeuner sur l'Herbe*, which shows a naked woman amid a group of men in contemporary dress, occasioned a huge rumpus. For Monet, the picture was a "revelation." Impressed by newly fashionable Japanese colored prints, which had been available in the shops since 1861, Manet had reduced the spatial depth of his picture and laid out individual areas as flat color. When Monet himself first exhibited at the Salon two years later, he decided to cause a similar stir

Women in the Garden, 1866
Oil on canvas
256 x 208 cm
Musée d'Orsay, Paris

Encouraged by his success at the 1866 Salon, Monet and Camille rented a cottage in Sèvres. This large picture was painted there, but the 1867 jury rejected it. In vividly contrasting colors, it depicts four young women occupying themselves in the garden without reference to one another.

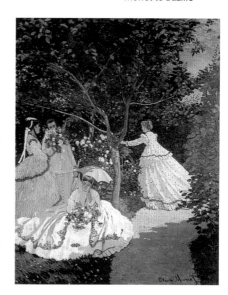

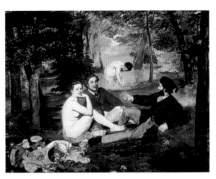

Édouard Manet
Déjeuner sur l'Herbe, 1863
Oil on canvas
214 x 270 cm
Musée d'Orsay, Paris

Manet's picture caused a sensation. It is both a criticism of the art scene's obsession with mythology in his day, and a clever assembly of only apparently related figures in an artificial context without spatial depth.

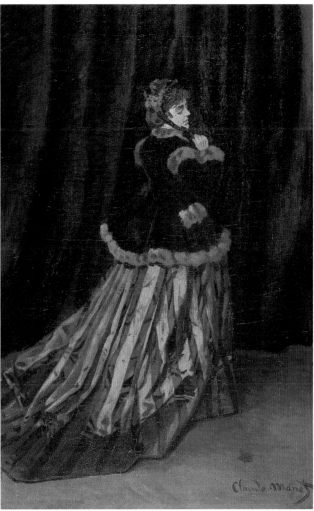

as Manet, the following year (1866), and in the same way become the talk of the art critics. He wanted to paint a huge oil painting six meters wide on the same subject in the open air – an almost impossible enterprise, for technical reasons.

However, the summer passed too quickly for him to complete the sun-drenched *Déjeuner sur l'Herbe*, so, with the opening of the Salon imminent, the painter had to produce another painting. It shows the elegantly dressed Camille Doncieux, Monet's model and later wife, in a rear view. The proven "classic" execution brought the hoped-for recognition, and led to the sale of several of his pictures.

The Woman in the Green Dress (Camille), 1866
Oil on canvas
231 x 251 cm
Kunsthalle, Bremen

Monet painted this picture in a mere four days. It shows Camille Doncieux, Monet's model and new girl friend, in a fine green silk dress that Monet had probably borrowed from his friend Frédéric Bazille. In spite of the traditional execution geared to Salon taste, novelist and art critic Émile Zola noticed the picture and benevolently commented on the "vivid, energy-laden canvas." The picture fetched a good price, Monet was even commissioned to do a copy.

The Young Family

After the great open-air composition *Women in the Garden* (page 26) had been rejected by the Salon jury in spring 1867, Monet found himself in desperate financial straits. More than ever, he was dependent on family help, especially as his partner Camille was now pregnant. Monet's father was only willing to continue helping his son if he terminated the unseemly relationship. In the circumstances, for the time being Claude had to yield to his father's wishes in order to provide Camille with the bare necessities. He left the pregnant woman in Paris and moved to his aunt's house in Sainte-Adresse.

Despite the family problems, Monet spent his time in Le Havre productively, working on no fewer than 20 seascapes. His relationship with his father also seems to have improved, since the latter appears in some of the pictures that were painted here, for example the *Terrasse de Sainte-Adresse.*

In August 1867, Monet's son Jean was born. The painter now spent more time in Paris again, and in spring 1868 submitted two land-scapes for the Salon. Although the jury accepted one of the pictures, Monet was discouraged, fearing he was making no progress in his paint-ing. He had Jean registered as his son – though without marrying Camille – and returned to Le Havre. His father thereupon withdrew his financial support completely. After a period of extreme privation, the

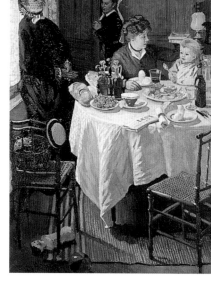

The Breakfast, 1868
Oil on canvas
230 x 150 cm
Städelsches Kunstinstitut, Frankfurt

As one of the few interior pictures by Monet, this picture is informative about the family's bourgeois way of life – though at the cost of enormous debts to friends and patrons.

Below:
The Mole at Le Havre in Bad Weather, 1866
Oil on canvas
50 x 61 cm
Privately owned

And in the evenings … I find a warm fire in my little house and a dear little family. If you could but see your godson, how cute he is now!

Monet to Bazille, 1868

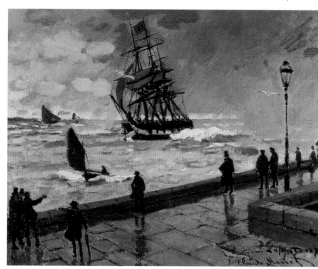

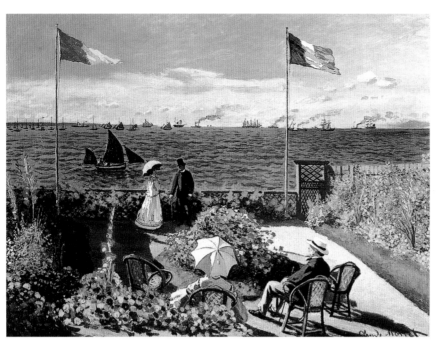

The Terrace at Sainte-Adresse, 1867
98.1 x 129.9 cm
Metropolitan Museum of Art, New York

With its decentralized, strictly structured composition (in which foreground, center ground, and background planes are not recessed into each other but appear staggered) and glowing colors, the picture is visibly inspired by Japanese color prints, which had become fashionable in the 1860s.

situation improved in June 1868, when Monet made some sales in connection with the international seafaring exhibition in Le Havre, and received his first commissions.

Thus, the young family spent a relatively happy year's end in new accommodation in Etretat, a seaside village on the English Channel near Fécamp. The painter recorded their new, more pleasant circumstances in his interior picture *The Lunch*, which shows Camille and Jean in a room furnished in middle-class fashion at an amply laid meal table. Monet was not a painter of the simple life, and in later years likewise avoided painting "ugly" things.

In spring 1869, the Salon turned Monet down again, but this time he was not to be discouraged, as he now set greater store by his further artistic development than a speedy career.

Katsushika Hokusai
View of Mount Fuji, 1829–1833
Woodcut
23.9 x 34.3 cm
British Museum, London

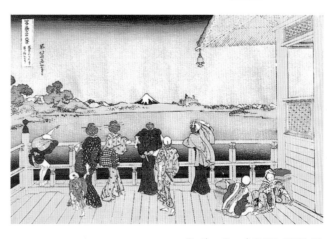

La Grenouillère

I am pursuing a dream – I want the impossible. Other painters paint a bridge, a house, a boat. They paint the bridge, the house or the boat, and they're done … I should like to paint the atmosphere enveloping the bridge, the house or the boat. The beauty of the mood they are in, and that is no less than impossible.

Claude Monet

Intending to start work on a major new project, in summer 1869 Monet and his little family moved to Saint-Michel, near Bougival on the left bank of the Seine. Close by was La Grenouillère, a popular rendezvous for day trippers from Paris. The grounds consisted of a huge raft with a tar roof supported by wooden columns, linked to the Seine island of Croissy by two footbridges. One led into a café with swimming facilities, the other to a tiny island with a single tree on it, and was therefore nicknamed Flowerpot. People would meet here, away from the conventions and strict morality of the city, to relax and amuse themselves.

By depicting scenes of modern life, Monet and his friend Renoir wanted to explore topics that suited their new painting techniques. No doubt they wanted the paintings to cause a stir in Paris as well. They were intent on further developing their techniques and finding artistic means of expressing the atmosphere of a place or natural phenomenon. Both artists set up their easels on the floating platform facing towards the Flowerpot – and the result has justly been called the "essence of Impressionism": two pictures in a radically new painting style showing contemporary society in relaxed mood.

Yet the works are highly different. Whereas Renoir even in this early picture shows himself interested in the human body and material objects, which he depicts with finely graded dabs of paint, Monet makes substantial progress with his lifelong theme of capturing momentary moods through light effects. Quickly applying color in broad, strongly contrasting, pastose brushstrokes, he reproduces an overall impression of the scene. A new approach is evident particularly in the handling of water surfaces; for Monet, water is no longer one objective feature to paint among many – as earlier in his *On the bank of the Seine at Bennecourt*, for example – but becomes a key element in his visual grammar.

This is because moving water reflects extremely transitory momentary pictures, and is thereby a symbol of momentariness in Monet's pictures. Moreover, the surface of the water as matter cannot itself be represented, as it always

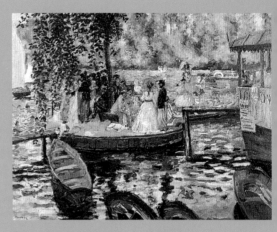

Pierre-Auguste Renoir
La Grenouillère, 1869
Oil on canvas
66 x 86 cm
Nationalmuseum, Stockholm

Below:
On the Bank of the Seine in Bennecourt, 1868
Oil on canvas
81.5 x 100.7 cm
Art Institute, Chicago

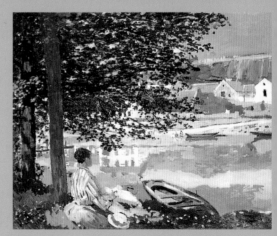

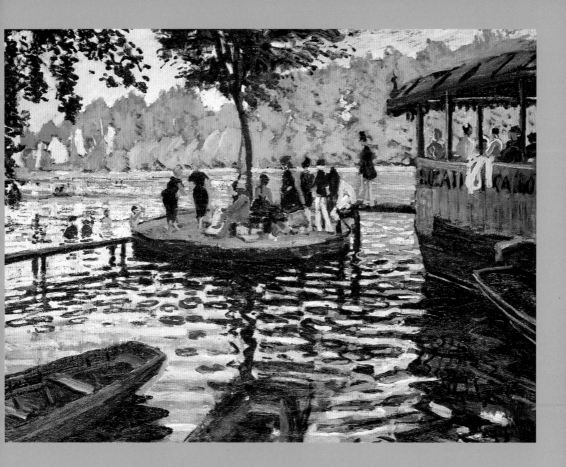

consists of reflections or refracted light and surrounding color – and is thus for Monet an ideal medium for the atmosphere of a moment created by light.

Above:
La Grenouillère, 1869
Oil on canvas
74.6 x 99.7 cm
Metropolitan Museum of Art,
New York

Escape to London

In June 1870, Monet and Camille finally decided to get married. Gustave Courbet, whom Claude had often met on painting expeditions to the Norman coast, was the best man. Possibly the looming military conflict between Prussia and France forced their hand, and indeed, a mere three weeks later the Franco-Prussian War broke out. This did not prevent Monet and his family passing a very relaxing time in the resort of Trouville. But when the domestic political situation worsened and a republic was declared in September, they decided to escape to London, in order to avoid Monet being drafted. Monet's close friend Frédéric Bazille signed up voluntarily, and was dead by November.

Life was hard for refugees in London. Monet lamented the British lack of interest in French art, and he found companionship only among fellow countrymen who had escaped to London as he had, and who regularly met in cafés. Here he met the painter Charles-François Daubigny again, who wanted to help him sell the paintings he had brought from France and put him in touch with Paul Durand-Ruel, an art dealer who came from Paris. Durand-Ruel immediately put one of Monet's Trouville seascapes on show in his London branch, and henceforth became Monet's most important dealer, from whose sales the artist covered the principal part of his expenses for a long time. Monet also met Camille Pissarro again in

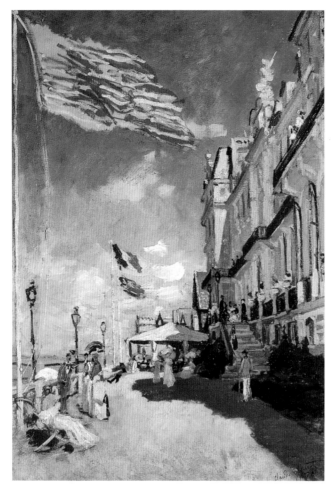

Les Roches Noires hotel in Trouville,
1870
Oil on canvas
80 x 55 cm
Musée d'Orsay, Paris

In summer 1870, Monet met Boudin in Trouville, who was likewise having a holiday there with his wife, and they had a carefree and productive holiday together. With just a few flicks of the brush, Monet sketched in a convincing image of a flag in a stiff breeze, on an untreated background. With no outline and the canvas showing through, the flag is broken up, giving it a sketchy character. Despite the tense political situation, the bright colors in this picture make the summer visitors seem quite relaxed on the promenade.

London, roaming through London's museums with him to study the works of Turner and Constable. He himself painted little at this time, a few views of the Thames and London parks being the principal works. Only during later visits to London would his negative attitude to the city change into a positive fascination for the fog effects of the Thames.

At the end of May 1871, shortly after Monet had received news of the death of his father, a peace treaty was signed between the German Empire and France, and the Monets decided to return to France at once.

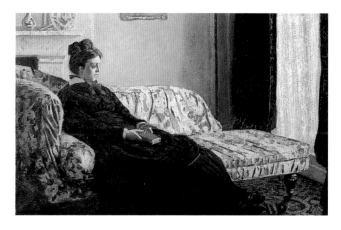

Madame Monet on the canapé, 1870/71
Oil on canvas
58 x 75 cm
Musée d'Orsay, Paris

Quite distinct in technique and subject matter from the Trouville works, this relatively small picture shows Camille in a pale light in a London interior. Dark, uncontrasting colors distinguish the picture, together with the unpretentious composition.

Hyde Park, 1871
Oil on canvas
41 x 74 cm
Museum of Art, School of Design, Rhode Island

Monet painted six pictures in London, including this calm park landscape in muted colors.

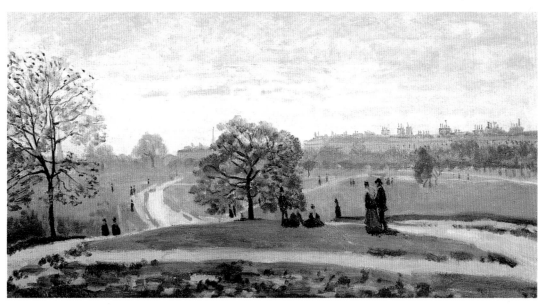

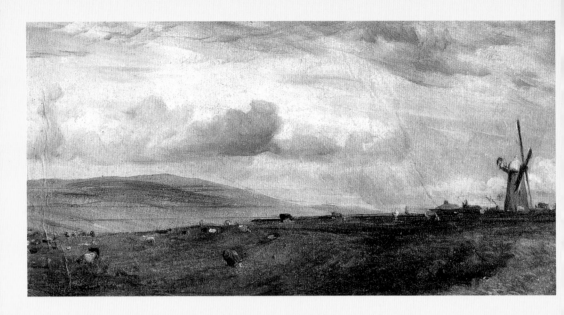

Constable and Turner

From 1820, John Constable (1776–1837) devoted himself almost entirely to landscape painting. More than any previous painter, he placed much emphasis on open-air nature studies as part of his work. After visits to Venice and Rome, where he studied the glowing local colors of Italian painting and the works of Claude Lorrain, he devoted himself to his native landscape of England. Claiming that painting was only another word for feeling, Constable rejected the traditional landscape composition in the sense of a lofty idealization. Instead, he studied the constantly changing appearance of nature with almost scientific perseverance, as his countless cloud studies demonstrate. However, the great vividness of his pictures may be attributed not just to the subject matter, but also to the lively, occasionally stippled brushwork. Also, Constable combined, for example, several shades of green to depict the lush green of his fields and foliage, in order to enhance their brightness. The traditional landscapes of his day lack intensity because only one shade of green was used to depict the whole world of vegetation. As a result of the new painting technique, Constable's oil paintings seem sketchy and, for many viewers, therefore incomplete. When Monet studied Constable's works in

John Constable
Landscape with Mill near Brighton, ca. 1820
Oil on cardboard
11.7 x 22.3 cm
Victoria & Albert Museum, London

John Constable
Cloud study, ca. 1820
Oil on cardboard
37.1 x 46.4 cm
Victoria & Albert Museum, London

the London museums, it must have been precisely these "unfinished", fresh, and unsentimental landscapes that encouraged him to systematically develop his own spontaneous painting technique.

Turner's visualization of natural forces

Steeped in the philosophy of Romanticism, Joseph Mallord William Turner (1775–1851) did not reproduce landscapes and their atmospheric effects in the naturalistic manner of Constable, but created mysterious metaphors, for example about the Creation and the cyclical character of natural forces. Appealing to the viewer's senses, Turner used color as a means of expression, to illustrate the conflict between elemental forces, which appear principally in the form of extreme weather conditions. The artist raised color to the level of an independent element of composition, at the same time liberating it from all concreteness. Turner's pictures are not therefore "composed" in traditional detail. Mostly, objects have no outlines and are not placed in the picture according to the laws of central perspective. More often, the frequently dramatic three-dimensional depth of his pictures is developed by strong color gradations and circular or spiral brushstrokes, which generate a certain vortical effect. Although Monet disliked

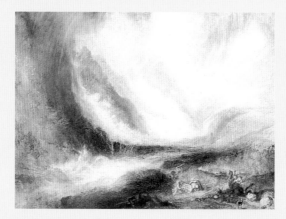

J. M. W. Turner
Storm in Aosta Valley, 1830
Oil on canvas
90.5 x 122.2 cm
Art Institute, Chicago

Below:
J. M. W. Turner
Rain, Steam, Speed (Great Western Railway), 1844
Oil on canvas
91 x 122 cm
National Gallery, London

the English painter for the "effusive Romanticism of his imagination", in his later works he adopted Turner's idea of "colored space". Admittedly he juxtaposed brighter colors, not mixing them like Turner. In terms of subject matter, both artists shared a commitment to technical progress. In his

picture *Rain, Steam, Speed*, Turner the idealist transfigured nature and technology into an aesthetic homogeneity, whereas Monet later showed only their cooperation, but the very choice of contemporary objects was unusual and revolutionary for the young Impressionists.

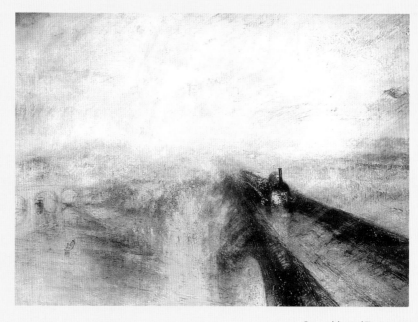

Windmill near Zaandam, 1871
Oil on canvas
48 x 73.5 cm
Ny Carlsberg Glyptothek, Copenhagen

As he frequently did later, in Zaandam, Monet seems to have painted on a boat. The unusual perspective and low viewpoint emphasize the water as the dominant element of this landscape. The Dutch landscape painters of the seventeenth century had already set their horizons remarkably low, building imposing cloudscapes on their landscapes. But unlike them, Monet sought no illusionist depth: extensive views into the landscape to a distant point of contact between earth and sky are discarded in favor of a contrast of fore and background that is almost like a stage set. Like Constable, Monet was explicitly interested in the play of natural forces and momentary impressions.

A Roundabout Return

In London, Monet had heard of a small place near Amsterdam called Zaandam whose atmosphere and light conditions painter colleagues – probably mainly the landscape painter Daubigny – had praised. Monet's return in early June 1871, therefore, took in a detour to this quiet, rather unspectacular place.

The family's financial situation was improving noticeably. Besides Camille's earnings – she gave French lessons as well as receiving a small inherited annuity – Claude had not only the receipts of Durand-Ruel's first sales in England but also his share of his father's estate. Thus they now had means for a tranquil sojourn in Holland. The flat land-scape with its numerous canals and windmills inspired him with enormous enthusiasm, so that he wrote to his friend Pissarro: "There's enough to paint here for a whole lifetime." The result was over twenty major landscape pictures during their five-month stay in Zaandam. In Holland, Monet's principal themes of sky and water were combined in an ideal fashion, working in the open, he painted restful, atmospherically dense pictures in earthy colors. Although one might assume otherwise, Monet seems to have taken no particular interest in early Dutch landscape painters, because not even the great art collections in Amsterdam could lure him away from Zaandam for long.

In November 1871, the Monets finally returned to a Paris that was scarred by the Prussian siege. They

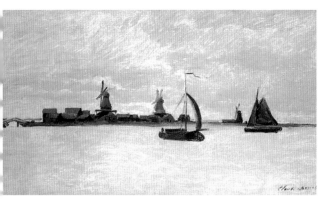

View over the Voorzaan, 1871
Oil on canvas
39 x 71 cm
Privately owned

Canal in Zaandam, 1871
Oil on canvas
43.8 x 72.4 cm
Privately owned

found accommodation at the Hôtel de Londres, situated near St-Lazare station, because Monet had found a studio a few houses further on in the rue d'Isly. At first, he worked on his studies from Zaandam, so as to be able to put them on the market. Indeed, the art supplier and picture dealer Latouche, who had already exhibited Monet before the war, did buy a landscape painted in Holland.

Monet soon renewed his contacts with the Paris art scene as well. He and his old teacher Boudin stirred themselves to help the noted painter Gustave Courbet, who had been arrested as an insurgent in March during the Paris Commune uprising against the Versailles government. Although normally apolitical, Monet displayed both commitment and courage – traits which marked his public behavior on other, if infrequent occasions.

The Impressionist 1872–1880

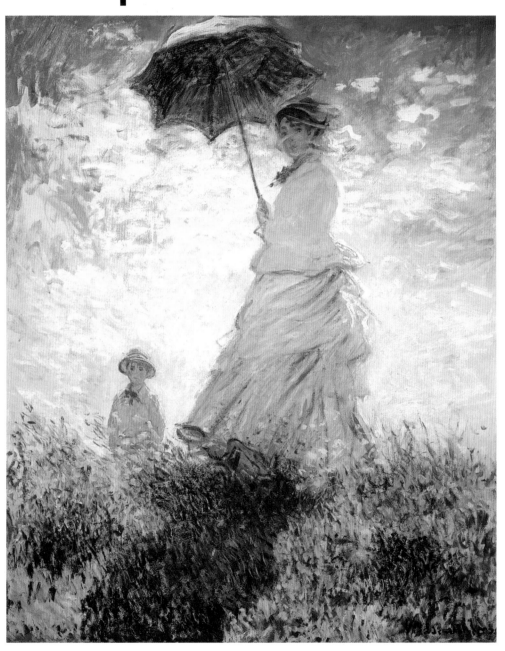

At the end of 1871, the Monets moved to Argenteuil, where the artist was to paint more than 100 paintings. With their glowing colors, light, rapid painting technique, and cheerful subject matter, they can be counted among the finest and best-known works of Impressionism. Encouraged by regular purchases by their new art dealer Durand-Ruel, Monet and his friends set themselves up as an artists' union, and showed their works in a group exhibition independent of the Salon. Though their art's breakthrough to fame failed to materialize, the painters could soon claim a certain notoriety as the "Impressionists," as they were sneeringly called by a critic. After the birth of a second son, the family moved to Vétheuil, in the country. Despite the premature death of Camille, the artist produced rapidly sketched landscape pictures of hitherto unknown color intensity and clarity of light effects.

Workers in a photo studio, ca. 1873

Monet at the age of 35

1872 Germany overtakes France as industrial power.

1873 Jules Verne publishes *Around the World in Eighty Days*.

1872 Works in Argenteuil and Paris on studio boat. Durand-Ruel buys 29 pictures.

1874 Second journey to Holland. First Impressionist exhibition.

1875 Auction of Impressionist works at the Hôtel Drouot.

1876 Second Impressionist exhibition. Paints four decorative wall paintings at the Hoschedés' country house, Rottenbourg.

1877 Paints at the Gare Saint-Lazare. Third Impressionist exhibition.

1878 Michel born, move to Vétheuil.

1879 Snow pictures in Vétheuil. Death of Camille. Monet paints her on her death bed.

1880 Exhibits at the Salon. Does not take part in 5th Impressionist exhibition. First one-man show. Trip to the coast of Normandy.

Opposite:
Woman with a Parasol (Madame Monet and her son), 1875
Oil on canvas
100 x 81 cm
National Gallery of Art, Washington

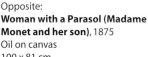

Right:
Édouard Manet
Monet at work in his studio boat, 1874
Oil on canvas
82.5 x 100.5 cm
Neue Pinakothek, Munich

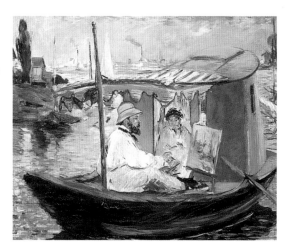

River Scenes of Argenteuil

After his return from Zaandam and a flying visit to Paris, Monet moved to Argenteuil, a growing industrial town on the Seine. As it could be reached in 30 minutes from Paris by train, many Parisians went there at the weekends to relax. Monet was thus also able to get to Paris easily at any time, to continue working on his paintings in the studio or meet fellow artists and new collectors at the Café Guerbois. He was now often visited in Argenteuil by his friend Renoir, and the two of them undertook joint painting excursions around the countryside. At about this time, Monet had his famous studio boat built (see page 39) in which he rowed out on the water with his easel and –

as previously in Holland – painted surprising and extraordinarily authentic water landscapes.

Of course, we may assume that the idyllic pictures of this time had little in common with reality. At the time, the Seine was already heavily polluted in the area by industrial effluents. Outraged contemporaries even called the river a "stinking sewer" with garbage floating around. As was his custom, however, Monet banished society's "unaesthetic waste" from his pictures. He interpreted the link between nature and technology as positive and harmonious, and integrated steaming trains or immense bridge constructions as favorite background motifs in his pictures.

Pierre-Auguste Renoir
Claude Monet, 1875
Oil on canvas
60 x 50 cm
Musée Marmottan, Paris

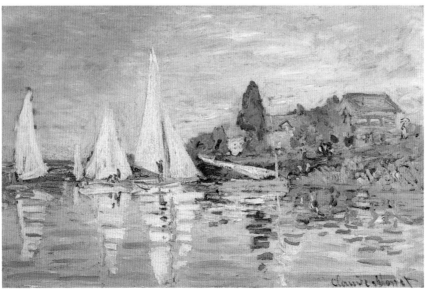

Regatta in Argenteuil, 1872
Oil on canvas
48 x 75 cm
Musée d'Orsay, Paris

Thanks to the low perspective and position of the painter on the water, the viewer feels part of the regatta and not like a mere spectator. The picture thus gains the credibility of personal experience, even though it is more interested in light reflections and color contrasts than detailed description.

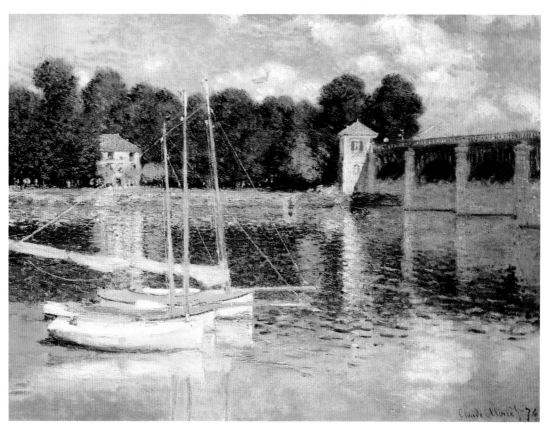

The Harbor of Argenteuil, 1872
Oil on canvas
60 x 80.5 cm
Musée d'Orsay, Paris

In Argenteuil, Monet's palette became noticeably brighter. He used mainly blue and violet instead of black to render shadow, and now tended to mix colors with white more often than before. The rendering of interplaying light and shade is masterly here.

The Bridge at Argenteuil, 1874
Oil on canvas
60 x 80 cm
Musée d'Orsay, Paris

Here, Monet worked out the changing structure of the water surface very precisely. For example, the water near the bank is like a mirror, whereas the slight current present in the center of the river throws up little ripples.

The Impressionist (1872–1880) **41**

The First Impressionist Exhibition

After returning from Zaandam, Monet, like most of his fellow artists, no longer submitted pictures to the Salon. The main reason being that, between 1872 and 1873, the dealer Durand-Ruel bought many works by the young artists. Their self-confidence boosted, at the end of 1873, they decided to arrange and finance an exhibition of their own. Monet, Renoir, Cézanne, Sisley, and Pissarro got together with Manet, Jongkind, and others as an organization of artists and announced their intention in Parisian art periodicals, calling on all serious artists at once to join their ranks. This unconventional advertising campaign was sensible, because the more artists took part, the less it would cost each of them.

Studio of Félix Nadar, the photographer, photo ca. 1861

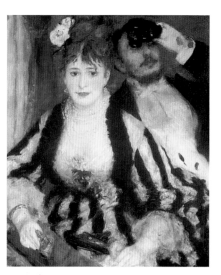

Pierre-Auguste Renoir **The Box**, 1874
Oil on canvas
80 x 64 cm
Courtauld Institute Galleries, London

Renoir was less interested in the metropolitan grandeur of the boulevards than in the world of entertainment, opera, and cafés. For him, people occupied the foreground.

Moreover, the friends wanted established painters to join the group so as not to be mistaken for painters rejected by the Salon.

On April 15, 1874, the artists' organization opened its first month-long exhibition in the former studio rooms of the photographer Nadar, in the Boulevard des Capucines. Monet himself showed 12 pictures, these included two of his masterpieces of the period, the *Impression, Sunrise* painted in Le Havre in 1872, and his latest picture *Boulevard des Capucines*. Whereas the relatively few visitors who attended the exhibition

Boulevard des Capucines, 1873
Oil on canvas
61 x 80 cm
Pushkin Museum, Moscow

This picture shows Monet's now mature Impressionist style. The colors have become livelier and rapid, as in *La Grenouillère*, but are applied to the canvas in thinner, shorter brushstrokes. Monet's view from Nadar's studios shows the hectic busyness of one of the broad boulevards that were typical of modern Paris. The figures on the right hand side, cut off almost casually, lend the picture the character of a photograph capturing a specific, transitory moment.

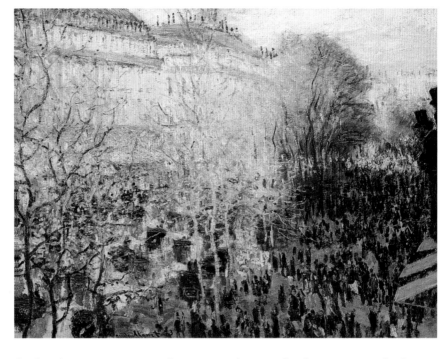

Paul Cézanne
The House of the Hanged Man, 1873
Oil on canvas
56.5 x 68.5 cm
Musée d'Orsay, Paris

This picture was among the few that were sold at the first group exhibition.

displayed amusement, critical opinion was divided. Some sneered forthwith that the painters had probably fired the paints at the canvas with pistols, while others admired the convincing rendering of a fleeting moment in *Boulevard des Capucines*. However, they criticized the sketchy execution that made the paintings look unfinished.

The most momentous review of the exhibition was written by the art critic Louis Leroy, who took Monet's title *Impression, Sunrise* as symptomatic for the whole style of the group and entitled his slating review "The Impressionists' Exhibition." The painters and friends thus reviled were not to be provoked but instead took the designation as a compliment, henceforth calling themselves Impressionists. This proved a clever move, as from then onwards they were known to a wider audience under their new name – although fame still eluded them.

Impression, Sunrise

If one wanted a single word to characterize [the artists of the 1874 group exhibition] and describe their endeavors, one would have to invent the term "Impressionists." They are Impressionists in the sense they do not depict landscapes but their impression of landscapes.

Art critic Jules-Antoine Castagnary

When Monet and his friends opened their first independent exhibition at Nadar's, they could not have chosen a more favorable moment. France was demoralized after losing the Franco-Prussian War, had had to cede important industrial areas such as Alsace and parts of Lorraine, and was forced to pay enormous reparations to the German Empire. To return to the old, glittering times and reinvigorate France, the government published an appeal in the art periodical *Gazette des Beaux-Arts* for artists to help to reconstruct the nation's moral and intellectual greatness. The result of this appeal was that in 1872, in the first Salon after the war, allegories of glory and military scenes were on display.

Many critics complained of the hollowness of these pictures and agreed that only landscape painting showed character. A week before the opening of the Impressionist exhibition, moreover, greater freedom for artists to organize their own exhibitions was approved. The Impressionist group picked up this mood of radical change very well. It was therefore Monet's concern to cause a sensation with his picture *Impression, Sunrise*. The very title was provocative, as the term had already been used in 1861 by the celebrated critic Gautier, passing judgment on a work by Daubigny in a negative but prophetic context. He accused the artist of being content to produce a sketchy impression of nature and shamefully neglecting the details in doing so.

In its sketchiness and summarizing appearance, Monet's picture does indeed stand out from his previous works. Even the colors are unusually dark for Monet.

As Monet himself stressed, the picture is not a topographically accurate view of the port of Le Havre. In the background, the smoking chimneys and

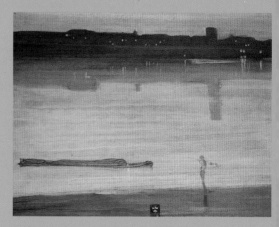

James McNeill Whistler
Nocturne in Blue and Silver: Chelsea, 1871
Oil on canvas, 50.2 x 60.8 cm
Tate Gallery, London

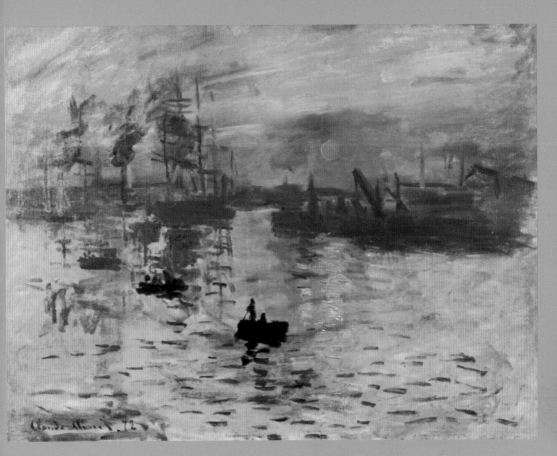

masts of freighters are only vaguely hinted at. In the foreground, three rowing boats can be made out on almost calm water. Given the historical context, the gleaming red ball of the rising sun could be taken as a symbol for the mood of a new era, but this interpretation would run contrary to Monet's otherwise apolitical oeuvre. The almost lyrical morning mood with its flat colors and abstract shapes is more reminiscent of the Thames views painted in London in 1870 by the American painter James McNeill Whistler, whom Monet may have met while he was in exile in London in 1870/71. Whistler thought painting should exist for its own sake, without the baggage of literary or moral ideas. In this, he agreed with the French Impressionists, who no longer regarded themselves bound by literature, mythology or history.

Impression, Sunrise has become the epitome of Impressionist painting not just because of the title but above all because of its character and execution. Monet was not interested in the pictorial content but more than anything in the changing quality of the light. In consequence he worked swiftly, applying the paint sometimes in dense brushstrokes. The picture records not a scene but a mood.

Impression, Sunrise, 1872
Oil on canvas
48 x 63 cm
Musée Marmottan, Paris

The Colors of the Impressionists

Édouard Manet
Argenteuil, 1874
Oil on canvas
149 x 115 cm
Musée des Beaux-Arts,
Tournai

painter also knew that shadow is never just black or gray, but colored. The actual color varies with the surrounding color and the color of the sunlight. This insight would strongly influence the Impressionists, as can be seen in comparing pre-Impressionist Manet's shadows with those in Renoir and Monet.
In the mid-19th century, scientists were also becoming more interested in the qualities of light and the way the eye sees. They concluded that color perception in humans is influenced by the individual's color sensations, and there can thus be no objective norms for the way

colors are seen. The Impressionists knew of these new findings from art periodicals, but had come to similar conclusions from their own visual experiences in the open air. As they painted direct from nature, they had to adjust their palettes to high brightness. They used 13 to 20 colors of the spectrum – colors like those of rainbows – and from the 1870s renounced the non-color black. The synthetic oil paints or pigments produced between 1840 and 1860, marketed in portable tubes, must have encouraged the Impressionists to devote themselves to representing sunlight once again. The new paints were more

Path through the Cornfields near Pourville,
1882, Oil on canvas
58.2 x 78 cm
Privately owned

Once open-air painting had become established, color became the artist's real medium as the nineteenth century wore on. The drawing, which had previously served as a basis for every painting, became increasingly subordinate to color, until it was wholly ousted by the purely painterly approach of the Impressionists.
Since the notion developed in the seventeenth century that painted pictures should match the appearance of the world, artists had become increasingly aware

of the inadequacies of their painting resources. It was considered impossible to represent sunlight or the bright tones of nature, as the paints available to them, with their relatively low brightness values, did not permit it. Light was therefore represented by simple light-dark contrasts. Finally, Delacroix recognized in the 1840s that color effects can be intensified by replacing this light-dark contrast in the composition by strong color contrasts, that is the juxtaposition of complementary colors. The

brilliant than the traditional ones and could be impasted more easily without running.

However, as many synthetic paints were less permanent, Monet and his friends used them very circumspectly. They made much use of ultraviolet, which no longer had to be expensively mixed, viridian (a brilliant emerald green), and ultramarine, a much cheaper blue than the traditional cobalt blue. The pronounced chromatic brightness of their pictures was of course not solely due to the new colors, which were often mixed with white, but also to their particular painting technique. The typical structure of color blobs resulted from the spontaneous brushwork and varying length and breadth of brushstrokes, giving their representations a brilliance through color contrasts.

The Impressionists were thus able to generate a brightness of light that envelops and permeates all objects in the picture. The often noted shimmer of colors in their pictures derives from these color blobs activating the subjective process of perception in the viewer. Soon afterwards, the *pointillistes* went a step further by no longer mixing colors at all but applying pure colors in such minute dots next to each other that they mix in the eye of the viewer and once again generate a homogeneous impression of color and form.

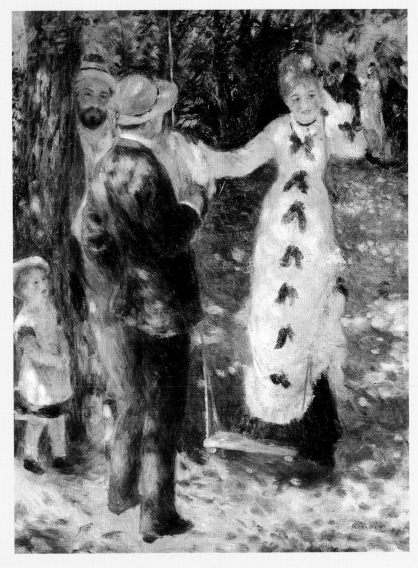

Pierre-Auguste Renoir
The Swing, 1876
Gouache on card
92 x 73 cm
Musée d'Orsay, Paris

Saint-Lazare Station

The poetry of the nineteenth century, it has to be said, is steam. Once it was only true poets who, borne by the wings of the imagination, reached unknown lands; nowadays, carried on the flaming pinions of steam power, everyone is a poet.

Jules Janin, 1847

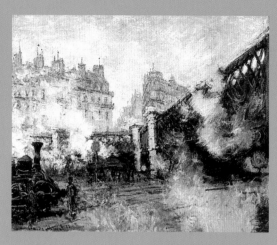

The search for new inspiration took Monet back to Paris again. There, he wanted to paint Saint-Lazare station, the terminus of the railway that brought him to Paris from Le Havre and all his other domiciles along the Seine. The railway was a symbol of technical progress and modern life. After all, it increased the mobility of greater sections of the populace and thus had as much influence on professional life as on the leisure activities of the cities. Excursions around the area or to the coast were no longer expensive or lengthy ventures. The busy terminals constructed in an architectural style of light steel and glass, were already known as the "new

The Pont de l'Europe at the Gare Saint-Lazare, 1877
Oil on canvas
64 x 81 cm
Musée Marmottan, Paris

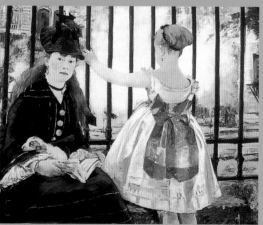

cathedrals of France," and it is therefore no surprise that stations became a popular subject for writers, painters, and even composers such as Berlioz, who wrote a song for railways.

Monet too was enthusiastic about railways as a pictorial motif. Trains often feature in the background of his landscapes or stride the foreground as a steaming colossus. Once he had decided to paint the Gare Saint-Lazare, according to a legend put about by Renoir, Monet wrested a permit from the station master to have trains placed and steamed at his discretion. Though it may lack credibility, the story at least bears out the notion that

the accusation of deficient composition repeatedly leveled at the Impressionists and Monet in particular, does not apply in this case. The picture displays a carefully arranged network of directions of movement and sightlines, which contribute as much to the picture's vividness as the contrasting color areas. Further proof of the sophistication of composition is the fact that Monet did preliminary drawings and in the end elaborated a whole series of pictures with eleven individual works.

Unlike Manet's picture at Saint-Lazare, whose subject is actually people, with steam and rails merely hinting at the setting, in Monet individual elements such as people, the façades of houses, and even the trains themselves are treated summarily in favor of the overall impression. Monet wanted to depict the interplay of steam and light, motion and machine noise, open space and interior.

Édouard Manet
Woman and Girl at the Gare Saint-Lazare, 1873
Oil on canvas
93 x 114 cm
National Gallery, Washington

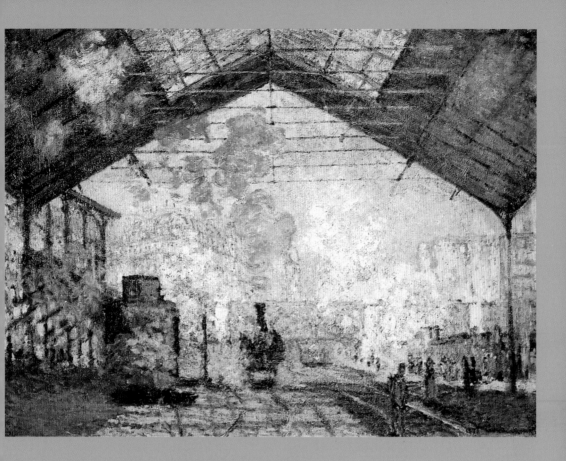

How impressively the station atmosphere is conveyed in these pictures is described by Zola: "You can hear trains pounding in and out of the station. That is painting today: modern scenes, lovely …"

The Gare Saint-Lazare,
1877
Oil on canvas
75 x 100 cm
Musée d'Orsay, Paris

Study, 1877
Pencil on paper
Musée Marmottan, Paris

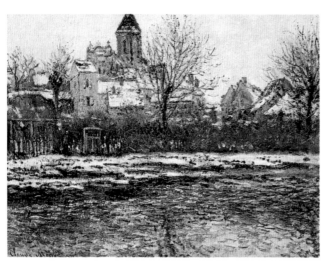

Relocation to Vétheuil

In summer 1878, the Monets moved further down the Seine to Vétheuil, a village untouched by industrialization. The family of four – a second son, Michel, had been born in Paris in March – here found a small house with a garden. Serious financial troubles afflicted the family, because Paris store director Ernest Hoschedé, a generous patron and client of Monet, declared himself bankrupt.

Vétheuil Church in Winter, 1879
Oil on canvas
52 x 71 cm
Musée d'Orsay, Paris

Vétheuil in the Val-d'Oise
Photo ca. 1890

He was forced to sell Monet's works for low prices, which reduced their market value perceptibly. The painter nonetheless remained friends with Hoschedé and his wife Alice, and even shared his house in Vétheuil with them. When Camille died a year later, in September 1879, Alice took responsibility for Monet's two sons as well as her own six children, so that the two families merged.

In this difficult and unhappy period, the artist painted nearly 200 landscapes in which unspoiled nature is the focal point. After the fourth presentation of Impressionist art in 1879 brought him only limited success, in 1879 and 1880 the impoverished Monet exhibited at the Salon once again. Encouraged by the public's growing interest, the publisher of the periodical *La vie moderne* invited him to exhibit his pictures in its editorial offices, his first one-man show. The show opened in June 1880, and helped to make Monet more popular. He was able to sell several of the works exhibited for good prices.

View towards Vétheuil, Thaw, 1880
Oil on canvas
71 x 100 cm
Privately owned

Winter landscapes represented a special physical challenge for open-air painters but had great public appeal, which Monet exploited by showing several works of this type at his first one-man show in Paris. Snow landscapes were popular as subject matter for the Impressionists, because the design could be neglected in favor of color and light effects.

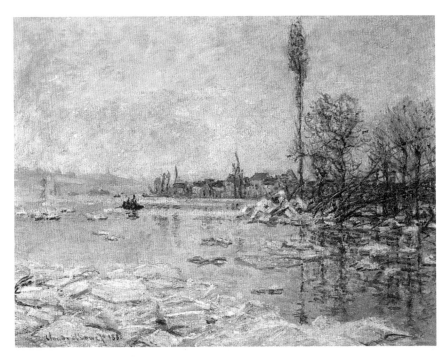

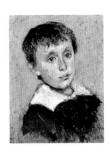

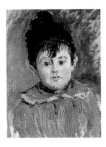

Above and above right:
Portrait of Jean Monet, 1880
Oil on canvas
46 x 37 cm

Portrait of Michel Monet, 1880
Oil on canvas
46 x 38 cm

Both Musée Marmottan, Paris

After Camille died, Monet found a loyal companion in Alice Hoschedé, who looked after his sons. After her husband left the house, Monet became responsible for eight children.

Camille Monet on her deathbed, 1879
Oil on canvas
60 x 81.5 cm
Privately owned

Camille's health had deteriorated since 1876, possibly as a result of a bungled abortion. The birth of Michel on March 17, 1878 totally debilitated her, and she died on September 5, 1879 aged 33. This picture, painted at her deathbed, is Monet's farewell to her.

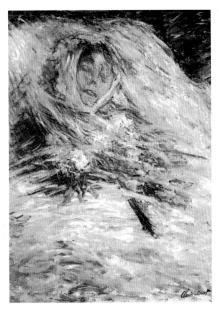

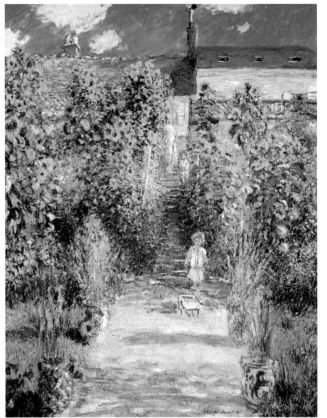

In Harmony with Nature

In summer 1881, before the move to Poissy, Monet painted his garden in Vétheuil, which ran down to the Seine. As previously in Argenteuil, the forthcoming departure caused him to cast a farewell look at his home and garden. The garden pictures with their idylls of summer flowers in splendor and Monet's children playing illustrate the artist's yearning for harmony with his family and nature.

Unlike the Argenteuil pictures, which conveyed the harmonious fusion of landscape and technical progress, Monet now depicted unspoiled nature in its beauty and vigor. People seldom appear in his pictures; where they do appear, they are integrated with nature as if they were mere accessories.

After Camille's death, a closer relationship developed between Monet and Alice Hoschedé, and when eventually her husband left the house, Monet suddenly became the father of eight children. More than ever he was bound in a stable family structure, and in planning his life had to bear in mind the welfare of his many children. Thus in November 1881 the now large family moved to Poissy, a somewhat bigger town also by the Seine, to enable the younger generation to obtain a proper education.

Monet's Garden in Vétheuil, 1881
Oil on canvas
151.4 x 121 cm
National Gallery of Art, Washington

Monet produces a striking contrast between the forces of nature and man in the depiction of tall sunflowers and small children, but without any of the mystical, transfigurative gloss of the German Romantic, Runge. Monet's picture bathes the scene in strong sunlight, as an expression of positive life forces.

Philip Otto Runge
Landscape, 1859
Oil on canvas
96.5 x 152 cm
Neue Meister, Gemälde-galerie, Dresden

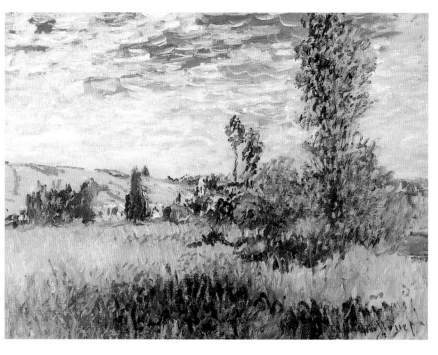

Landscape at Vétheuil, 1880
Oil on canvas
59.7 x 80 cm
Glasgow Art Gallery

Monet's summer canvases from Vétheuil are notable for their brilliant light effects in gleaming colors which he applied more broadly and rapidly than ever before. Monet now made more use of color and brushwork, to give expression to his explorations of nature, not to describe in detail what he saw. This subjective painting technique was already evident in earlier pictures, but it now met with greater public acceptance.

Everything is all the more depressing because I have to leave Vétheuil this month. I have to look round for something new, and that will mean a fundamental change for me.

Monet, 1881

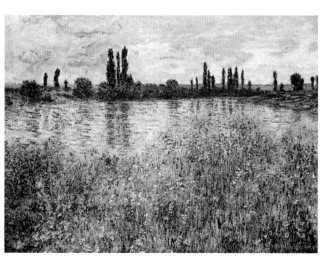

Seine Bank near Vétheuil, 1880
Oil on canvas
73.4 x 100.5 cm
National Gallery of Art, Washington

The absence of human figures in Monet has several causes. Whereas at a somewhat later date Van Gogh had to do without models for sheer lack of money, Monet could easily have secured agricultural workers from Vétheuil as models. However, it is only his family that crop up in some of his garden and landscape pictures. This circumstance makes it clear Monet wanted to work undisturbed on his experience of nature. An additional consequence is that the pictures thereby lose all social and temporal reference, and become entirely apolitical and universally valid.

Travels and Retreat

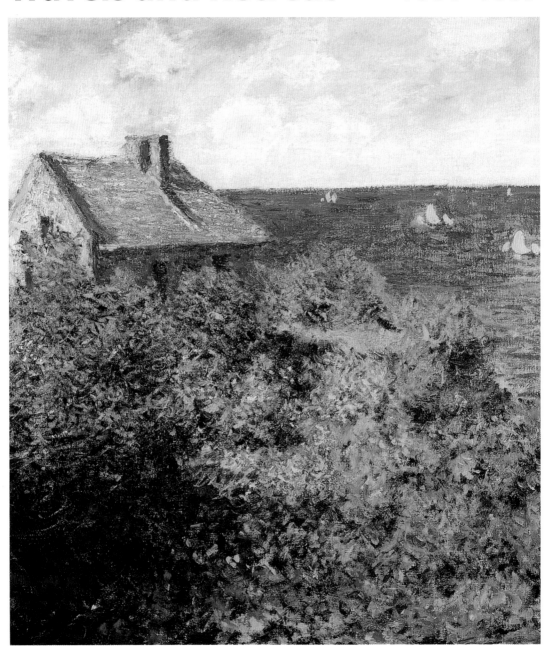

From 1882, Monet no longer submitted his pictures either to the Salon or to the Impressionist exhibition. Like his artist friends, he intensified his efforts to develop a distinct individual style, and incessantly sought new, sensational subject matter. He therefore decided to travel. In particular, he was profoundly impressed by the Mediterranean landscape of Italy with its world of exotic flora and colors. With great effort, he captured this "terrifying," and at the same time fairy-tale, atmosphere of color in his landscapes. After three months, Monet returned to his new home in Giverny and, with interruptions for further painting sorties, began to make his home as he and Alice desired it. In Giverny, the prosperous artist found adequate subject matter and gradually settled down.

Construction of the Statue of Liberty, 1884

Monet ca. 1887

1886 France gives USA the Statue of Liberty to celebrate 100th anniversary of independence.

1889 The opening of the controversial Eiffel Tower as part of the World Exposition.

1881 Monet is now able to sell his pictures at good prices. He and Alice Hoschedé move to Poissy.

1883 Trip to Etretat. Moves to Giverny.

1884 Travels to the Italian Riviera. Paints his most color-filled pictures.

1886 Great Impressionist exhibition in New York by Durand-Ruel. Trip to Brittany.

1887 Discusses an exhibition in London with art dealer Theo van Gogh, brother of Vincent. Reputation in USA grows.

1888 Travels to the Côte d'Azur. Paints views of Antibes. Starts his first series (*Haystacks*).

1889 Exhibition in London. Joint exhibition with Rodin at Durand-Ruel's, where he shows 145 works.

Opposite:
Fisherman's House in Varengeville, 1882
Oil on canvas
60.5 x 81.5 cm
Museum of Fine Arts, Boston

Right:
Painted Door Panels in Durand-Ruel's apartment, 1882–1885
Oil on wood

Tour de France

After his first one-man show in Paris, Monet's reputation started to spread, so that his financial situation finally improved as well. The dealer Durand-Ruel also resumed buying pictures regularly at good prices.

Arriving in Poissy, the painter found little in the way of interesting subjects, although one advantage compared with Vétheuil was that the town was on the railway line. This meant he could easily make prolonged excursions to the coast of Normandy, which exercised a constant fascination. In 1882 he initially traveled by himself, but later went with his family to Pourville-sur-Mer, which was a bathing resort near Dieppe. As already in Vétheuil, it was not the marks of civilization that most interested the artist, the numerous beach establishments and hotels, but the distinctive coastal landscape and cliffs. In the solitude of nature, work proceeded apace.

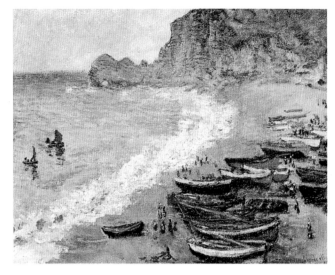

The Beach at Etretat, 1883
Oil on canvas
65 x 81 cm
Musée d'Orsay, Paris

The coast at Etretat, photo around the turn of the century

Latterly, Monet had worked on up to eight canvases at a time, in order to capture rapidly changing weather and light conditions. Altogether he did nearly 100 seascapes, many of which he showed at the seventh Impressionist exhibition in April 1882. In January of the following year, the artist was drawn to the

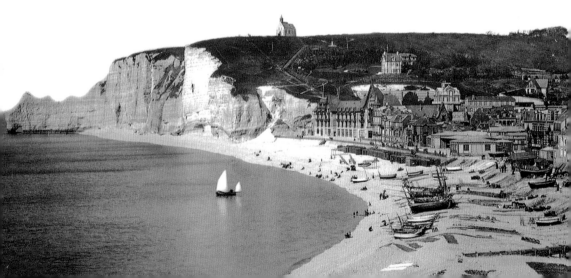

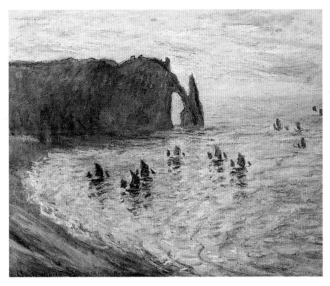

fishing village of Etretat near Le Havre, renowned for its strange coastal formations and undercut chalk cliffs. Although Monet once again worked on several pictures at once because of the greatly varying tides, he actually returned home with only twelve pictures. After his second one-man show, organized this time by Durand-Ruel, which was less successful, Monet decided at the end of 1883 to accompany his painter friend Renoir on a journey to the south, to Italy.

The painter [Monet] lurked in front of his subject, waiting for sun and shadow; with a few strokes of the brush he caught a beam of light or passing clouds ... Another time, he dragged down with his hands a shower of rain sweeping across the sea and smacked it on to the canvas.

Guy de Maupassant, 1886

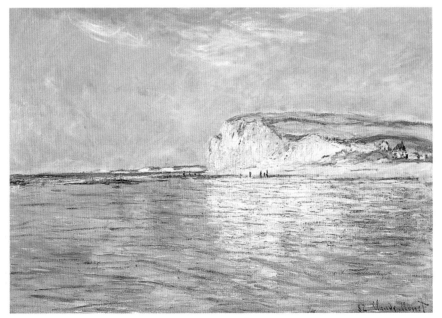

Above:
Sunset, 1886
Oil on canvas
60 x 73 cm
Pushkin Museum,
Moscow

Pourville at Ebb Tide, 1882
Oil on canvas
61 x 81.2 cm
Museum of Art,
Cleveland

On the coast of Normandy, Monet painted some masterly seascapes, predominantly in clear, pure colors these were applied in open, vigorous brushstrokes.

The Blue Light of the South

Before Monet set off with Renoir for the south, he looked for a new home. This time, it was to be a place where he could both live and work, unlike Poissy, which had provided nothing in the way of artistic stimulus. In April 1883, he rented an estate with a large garden in Giverny, 50 miles west of Paris. Here he intended to settle down after his forthcoming trip.

At the end of 1883, Monet and Renoir finally traveled to Genoa via Marseilles. It soon became evident that the time for fruitful joint painting trips was over. Both artists had found their own styles and were, moreover, interested in different subjects, so that working together neither inspired them especially nor was indeed practical. In addition, both painters were becoming more

Bordighera, 1884
Oil on canvas
64.8 x 81.3 cm
Art Institute, Chicago

Impressed by the different quality of Mediterranean vegetation, Monet did not paint typical city views here but once again returned to the theme of nature's predominance. Grotesquely twisting tree trunks wind across the picture, their luxuriant foliage obscuring the actual subject.

The Castle at Dolceacqua, 1884
Oil on canvas
92 x 73 cm
Musée Marmottan, Paris

careful about overlapping subject matter, in order not to lose anything of their originality (and therefore commercial appeal) in an art market that had indeed become more liberal but also increased in competitiveness. This was especially important for Monet at the age of 44, because since 1882 he had exhibited neither at the Salon nor the Impressionist exhibitions, and was therefore more dependent than ever on critics and collectors for success.

The result was that in January 1884 Monet settled on his own in Bordighera, a small town situated on the Italian Riviera, from where he could undertake excursions to the surrounding mountain villages and Dolceacqua in the Nervia Valley. Monet was immediately taken by this strange, exotic landscape, but first had to accustom himself to the intense meridional colors.

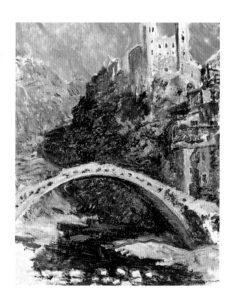

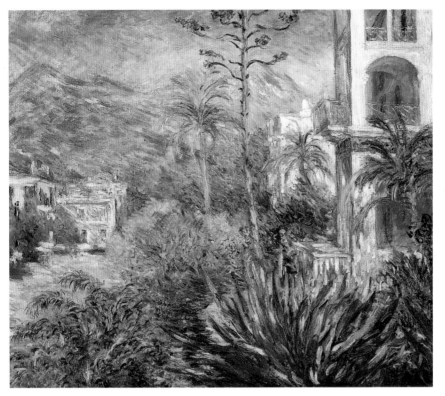

Villas in Bordighera, 1884
Oil on canvas
115 x 130 cm
Musée d'Orsay, Paris

The principal villa shown is the Villa Garnier, built by the famous French architect Charles Garnier, but it was not the building that interested Monet. He just used the architecture as a feature in the composition, to enhance the overall effect – a technique influenced by photography. Whereas other painters of his day – for example Manet, and particularly Degas – often used the technique, pictures of this kind, whose dynamism depends mainly on selecting the right frame, are rare in Monet. To this extent, the structure of the picture reflects what the choice of colors already suggests, that Monet felt very uneasy in the light and landscape of the Mediterranean, and tried to master it through the use of unconventional means – unsuccessfully in his own view.

He noticed tones hitherto totally alien to him. The basic color of the sky and atmosphere (gray-blue tending to violet), the pink and apricot-colored flowers, and emerald green sea water excited him greatly. These new colors and moods , which changed more quickly than on his native coast, left him almost in despair. He feared he might be unable to capture the character of this landscape, and in his letters to Alice continually complained of his problems with the choice of color. He finished scarcely any of his pictures, although he worked to the point of exhaustion on up to six canvases a time. Even so, he brought over 40 painted canvases back to Giverny, where he reworked them. In the event, he only exhibited two of them in 1885, at the gallery of Georges Petit.

Four years later, he undertook another journey to the south, to Antibes. It would be his last for the time being.

Monet in Giverny

When Monet moved to Giverny in 1883, his oeuvre already comprised more than 800 paintings, including numerous garden pictures and flower still-lifes. The search for subject matter and impressions of nature had driven him hither and thither for a quarter century, before he found this place, which in the next 40 years he would refashion according to his own ideas.

In Giverny, Alice and Claude slowly created a domestic idyll, and though they left it for short trips,

it would increasingly become their point of reference. Indeed, it still exercises great fascination for visitors from all over the world. From this period, the family again came to be very important to the painter, and between 1885 and 1887 he principally created landscapes with largish figures, for which mainly his step-daughters acted as models.

In the late 1880s came a sustained improvement in Monet's circumstances – he had finally achieved success. The second exhibition by

Field of Poppies in Giverny, 1885
Oil on canvas
61 x 81 cm
Hermitage, St. Petersburg

Monet gradually completed the process of settling down by internalizing the nature surrounding him. He painted this view in two very similar versions, for example.

Petit in June 1886 was more successful than the first the year before, and two exhibitions of Impressionist art held in New York that were organized by Durand-Ruel aroused rapturous enthusiasm. Monet was not too keen on his transatlantic success, as he disliked his pictures from France being sold to the "Yankees." He saw his art as a permanent component of French culture and therefore wanted it to be closely linked with his homeland. Yet it should be noted that Monet's henceforth solid financial position would have been inconceivable without the earnings from sales in the USA.

The earth is colored by the mist of fragrances, the sky overcast as if by a secret.

Claude Monet on the Givery Landscape

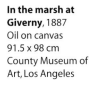

In the marsh at Giverny, 1887
Oil on canvas
91.5 x 98 cm
County Museum of
Art, Los Angeles

Claude's and Alice's sons were rarely at home because of school, but Alice's daughters Marthe, Blanche, Suzanne, and Germaine continued to live in Giverny. The picture shows Suzanne painting one of her sisters.

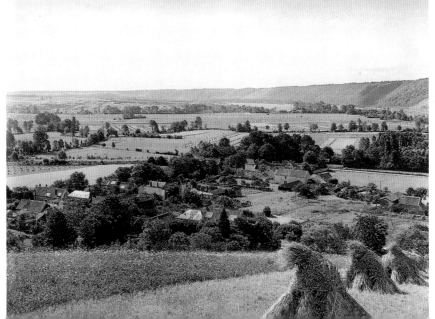

View of Giverny
Photo ca. 1930

Monet and the Art Market

From this day forth, Durand-Ruel supported us all. It was a heroic venture. It would take a separate study to clarify the role that this great art dealer played in the history of Impressionism.

Claude Monet

With the Impressionists came a change in the relationship between artist and public. They rejected the Salon as a forum for their works (only Monet exhibited there for the last time in 1879 and 1880) and organized independent group exhibitions that were no longer presided over by a jury. This was only possible at a time when the art market was being liberalized. The bourgeoisie, which had been flexing its muscles since the Second Empire, played a major role in this, generating a new potential customer base and thereby in part determining tastes. From 1860, with the gradual dissolution of the state-controlled Salon, which was finally privatized after 1880, Parisian dealers experienced an economic upturn. At first, however, it was the paint dealers who meant most to the young painters rejected by the Salon, as these exhibited the latter's paintings in their windows. The paint dealer Louis Latouche for example was

Galerie Goupil
Photo ca. 1880

among Monet's first buyers. For the rest, opportunities for unknown artists to exhibit were rare. This in turn meant that their work could not be discussed by critics, and they continued to remain unknown. The greatest forum for contemporary art in France was the traditional auction house of Hôtel Drouot, since the sole national museum that had a collection of contemporary art, the Musée du Luxembourg, possessed under 200 works in 1850. Indirectly, Drouot exercised an important function in disseminating contemporary art, as whole private collections came under the hammer at

Art dealer Paul Durand-Ruel
Photo ca. 1895

auctions, including in 1878 that of bankrupt store owner Ernest Hoschedé, Monet's patron in earlier years. On this occasion Monet, whose works constituted a third of the lots at the Hoschedé auction, met Georges de Bellio, a doctor, the customs official Victor Choquet, and the art dealer Georges Petit, who all regularly bought pictures from him later. From 1884, Petit continually exhibited Monet in his Exposition Internationale. From 1888, Monet was also under contract to Theo van Gogh, the brother of Vincent, who ran the Goupil branch of the house of Boussod & Valadon. Due to him, one of his pictures first

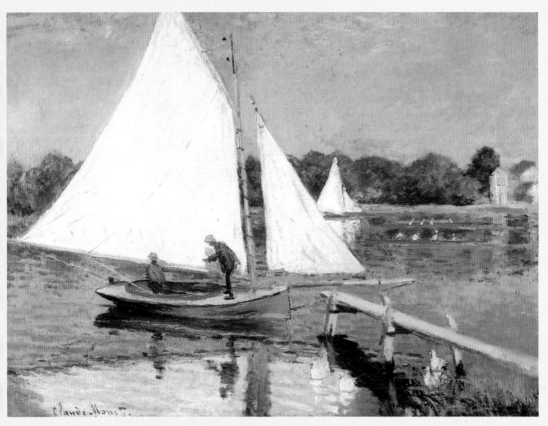

made 10,000 francs in London in 1889, at a time when a Monet changed hands for an average 1,000 francs. Well before Petit, Paul Durand-Ruel was the most important dealer for the Impressionists. Monet became acquainted with him in 1870, during his exile in London. Durand-Ruel developed a completely new approach to sales that served both his own and his artists' interests. Once he had gained confidence in an artist, he bought up all his pictures and thus acquired a monopoly over that artist's work, putting it on show in major exhibitions at home and abroad. Monet owed his greatest financial successes from the 1880s on, and his reputation in Europe and the USA to him. Even in his lifetime, Monet's works became objects of speculation, sale prices reflecting rising or falling demand. Nowadays they rank among the most expensive objects in the international art trade. In this way, a painting in the *Waterlily* series was sold for £18 million in 1998, a work from the *Grand Canal* series for US$11 million, and *Yachtsman in Argenteuil* for US$8.2 million. These prices can rise by 10 per cent from

Yachtsmen in Argenteuil, 1874
Oil on canvas
61.9 x 80 cm
Privately owned

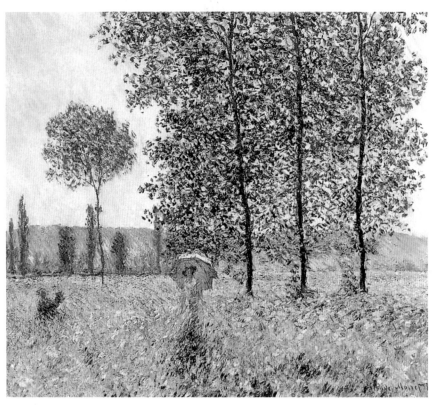

Under the Poplars in Sunlight, 1887
Oil on canvas
74.3 x 93 cm
Staatsgalerie,
Stuttgart

Suzanne Hoschedé and one further person are positioned in a flower-meadow in front of a group of trees.
The picture is arranged in the principles of classical space construction, in which the trees define its depth. It's vividness is created by nervous changes of painting-directions of hundreds of color-dots.

In the Skiff, 1887
Oil on canvas
98 x 131 cm
Musée d'Orsay, Paris

Beauty in Repose

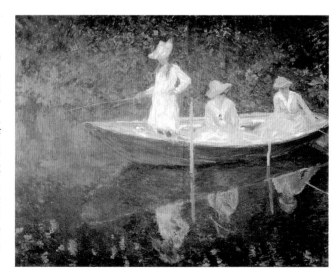

Unlike his Impressionist friends Renoir, Degas, and Caillebotte, Monet had always loved rural surroundings, but settling in Giverny in no way meant withdrawing from the Paris art scene or even the end of all traveling. In fact, in the 1880s and 1890s he undertook regular painting trips lasting up to three months, and actively corresponded with the most influential French painters and writers of his day. On the other hand, the repose that entered his life also became evident in his work.

His pictures now radiate a greater serenity and show a more relaxed hand. From 1886, he painted some pictures that show his stepdaughter Suzanne holding a parasol in a flowery meadow. These works exude a peaceful and untroubled atmosphere; in their light coloration and straightforward pictorial composition, they look the epitome of beauty and harmony.

In pursuit of this ideal, Monet also developed new approaches to the treatment of what is probably his most important pictorial motif: after a phase of powerful seascapes, seeming to symbolize the painter's struggle with nature, his water landscapes were now to become strikingly calm. The surface of the water is frequently completely still, and thereby becomes a fascinating, semi-transparent medium. On the one hand, it exposes the depth of the water and the life it conceals, on the other it reflects the world above. The first works on this subject, dating from 1887 on, were already distinguished by the lyrical, meditative mood that Monet would bring to perfection later in his water-lily pictures.

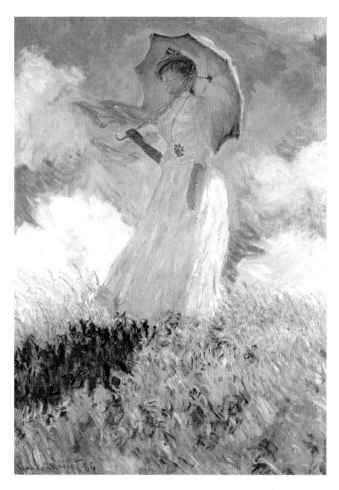

Open-air study (woman facing left), 1886
Oil on canvas
131 x 88 cm
Musée d'Orsay, Paris

This picture shows a rare full-length figure again in Monet's step-daughter Suzanne. Unlike the similar portrait of Camille earlier (cf. page 38), the artist did not reproduce the facial features of his model but smudged them, as he did in other full-length pictures of this time. Monet now treated his figures like landscapes, whose physical qualities he presents summarily and no longer in detail. As the figure is not differentiated, it does not distract the viewer from the overall composition, which once again was intended to express the unity of nature and man, not the latter's superiority.

The Law of the Series

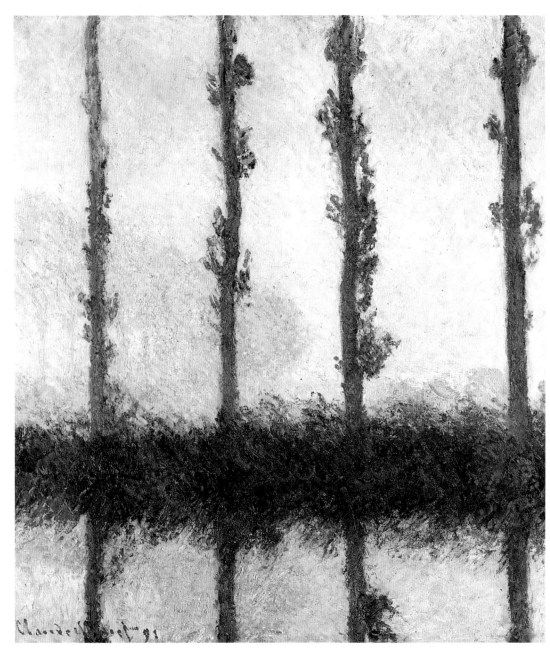

The objects in the pictures dwindled in importance. The painter devoted himself wholly to the task of rendering the immediacy of a mood. Mostly he worked on several pictures at once, to capture rapidly shifting light effects, so that we get a connected series of pictures depicting a sequence of subtle atmospheric changes. To bring out this effect, the painter increasingly reworked his pictures in the studio – a practice that indicated he was effectively outgrowing Impressionism in the strict sense.

Monet achieved extraordinary successes with the new picture series. He was now unquestionably the top French painter of his generation. Yet these years were also scarred by personal reverses, especially with his sight declining.

The Wright Brothers on a test flight, 1902

Monet ca. 1905

1890 Death of Vincent van Gogh.

1891 End of the Indian wars in the USA.

1894 Dreyfus affair in France (until 1906).

1895 First film show in Berlin. Discovery of X-rays.

1900 France is second only to Britain as a colonial power. Caruso records his first disks. Invention of the osmium bulb. World exposition in Paris.

1903 Death of Pissarro. First powered flight.

1905 The Fauvist group of painters around Matisse cause a sensation in Paris. Einstein publishes his theory of relativity. In Dresden, the Expressionists join forces as Die Brücke group of artists.

1890 Acquires the estate in Giverny.

1891 Death of E. Hoschedé. *Haystack* exhibition. Like Renoir, refuses award of Légion d'Honneur.

1892 Rouen Cathedral series. Exhibition of the poplar series in Paris.

1895 Three-month trip to Norway.

1897 Marries Alice Hoschedé. First water-lily pictures.

1899 Journey to London. Series with views of Thames and Parliament.

1904 Thames series successful. Travels to Spain by car.

1905 Major exhibitions in Europe and the USA.

1907 Journey to Venice. Paints over 30 views there.

1908 Completes 30 water-lily pictures. His eyesight deteriorates.

Opposite:
Four Poplars, 1891
Oil on canvas
81.9 x 81.5 cm
Metropolitan Museum, New York

Right:
Honoré Daumier
Caricature in *La Charivari*,
19 January 1865

"Do you think I'll have difficulty getting a good price for this picture?"
"Not if you find someone who's mad on poplars."

The Haystack Exhibition

On May 4, 1891, Durand-Ruel opened an exhibition in his gallery in Paris with 15 haystack pictures plus seven other landscapes by Monet. The public was enthusiastic and confused at the same time, because no previous one-man show had had such severely limited subject matter. The commonplace subject itself was not such a surprise. Haystacks had appeared earlier in pictures by the realist Millet, for example, and also in early works by Monet himself. But whereas in such pictures the conceptual connection remained intact – that is to say the haystack could, as usual, be regarded as a quantity of hay heaped up in a field – Monet radically redefined his haystack (and thereby pictorial objects in general) for the first time:

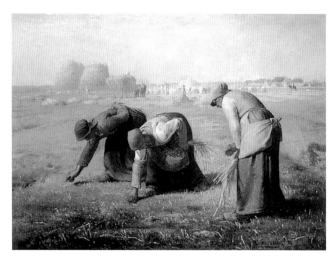

François Millet
Women Gleaning, 1857
Oil on canvas
84 x 111 cm
Musée d'Orsay, Paris

Haystacks at Twilight,
1884, Oil on canvas
65 x 81 cm
Pushkin Museum,
Moscow

by depicting it serially, he detached the motif of "haystack" from its meaning and made the object a neutral projection area for light and atmospheric effects. By using just one object, whose position remained virtually unchanged, Monet recorded the subjective perceptions of color and atmosphere of a short section of time. This impression of a basic atmospheric ground he called *enveloppe*; his investigations would continue over the coming decade in numerous series of pictures.

The pictures in Durand-Ruel's gallery hung all together in a room, so that their reference to each other was obvious. However, visitors were impressed not only by the serial character but also by the technical bravura of the execution. Vassily Kandinsky, the painter, later recalled the deep impression that one of the haystack pictures made on him at an Impressionist exhibition in Moscow in 1895. "That it was a haystack I

learnt from the catalog. I couldn't recognize it ... But what was completely clear to me was the hidden power of the palette such as I had never even suspected, that exceeded all my dreams."

The Paris exhibition was a great success. Monet's pictures were meantime becoming popular as objects of speculation whose market value steadily rose. Particularly American and Japanese collectors were interested in the haystack pictures, so that, despite his previously declared intention to the contrary, he agreed to split the series up and sell the works individually.

Haystack with Snow Effect in the Morning, 1891
Oil on canvas
65.4 x 92.3 cm
Museum of Fine Arts, Boston

Haystacks in Hoar Frost (at Midday), 1891
Oil on canvas
65 x 92 cm
National Gallery of Scotland, Edinburgh

Haystacks with Snow Effect at Sunset, 1891
Oil on canvas
65.3 x 100.4 cm
Art Institute, Chicago

Monet had already started painting landscapes with smaller hayricks in 1884/85. He now adopted the subject for a comprehensive series of 25 canvases, in which one of two haystacks form the sole pictorial content, at various times of the day and seasons. The colors are now more intensive and applied in more vigorous brushstrokes than before, so that dense, glowing areas of color arise. Monet makes the compact areas come alight with numerous small brushstrokes.

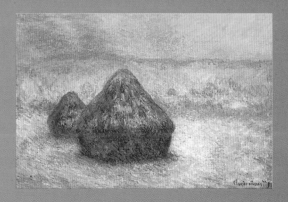

Rouen Cathedral

The miracle of Monet's feeling is that he reproduces masonry vibrating, bathed in gleaming waves that crash apart in a glittering spray and disintegrate. The time is up for immutable, dead pictures. Even stone is now alive, one can sense it changing. It fades. We see it fade.

Georges Clemenceau, 1895

On February 5, 1892, Monet traveled to Rouen. He now wanted to develop the idea of capturing the specific atmospheric mood of a period of time within the context of an architectural view. He set up his easel in a fashion shop, from the window of which he had a good view of the west front of the Gothic cathedral. Monet recorded very short periods of time, changing the canvas almost every half hour in order to be able to catch the slightest changes of color. In this way a chronology arose that seems to suggest, particularly in comparing the pictures, that Monet was aiming at a true depiction of time passing (though morning pictures predominate in the series of 28 pictures, as the female customers of the shop soon took offense at his permanent presence). In fact, the opposite is the case. What mattered to the

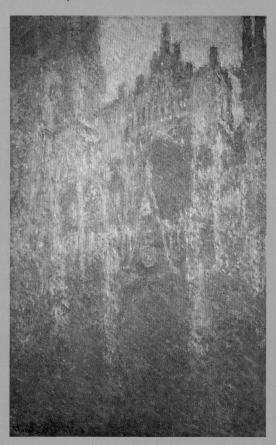
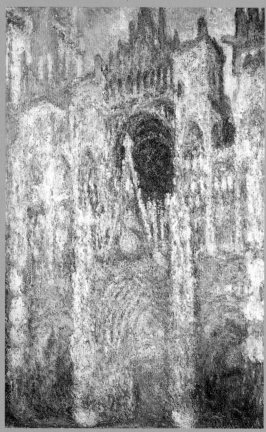

painter was to capture all possible atmospheric effects of light and color, and document the effect of the slightest difference in lighting on the overall subjective impression. Interestingly, the particular choice of Rouen Cathedral as a subject demonstrates the central problem in Monet's attempt to capture a momentary impression and make it comparable with another momentary impression. The execution of detail required to render the richly decorated façade and the sheer scale of the pictures involve work lasting far longer than the moment concerned. Consequently the works must be regarded not as authentic views or at least the spontaneous records of moods but remain what (non-photographic) works of art always were, synthetic creations defined by the will of the artist. In this respect, Cézanne's remark that Monet was "all eye – but what an eye!" is only half true. Monet did indeed investigate the visual impression, and mostly did not want to depict more, but the artistic process was intellectually directed, and generating color harmonies was to a certain degree a post-hoc action.

The West Front of Rouen Cathedral, 1894
All oil on canvas
100 x 65 cm

From left to right:
Early morning
Museum Folkwang, Essen

In the morning sun
Musée d'Orsay, Paris

In the afternoon
Musée Marmottan, Paris

Late afternoon
Larock Granoff Collection, Paris

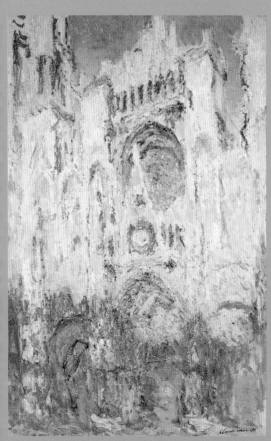
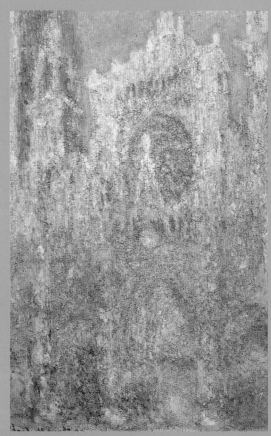

The Backwater of the Seine

After a two-month trip to Norway in 1895, in the following year Monet went on painting expeditions along the Seine. All his life, water proved a fascinating motif for him. He was constantly exploring its changing nature, within which he distinguished two aspects: whereas in his seascapes the sea was frequently churned up, revealing its dominating character, inland waters in his pictures are mostly calm. Consequently, in the sea pictures the water ranks as a distinct component of design, whereas in the river and lake pictures it serves principally as a surface for reflecting light, color, and the surrounding landscape.

The backwater of the Seine at Giverny with its lush riparian vegetation offered the painter ideal conditions for studying light conditions

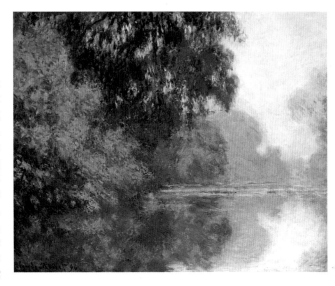

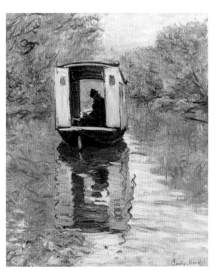

during the course of the day. Operating from his studio boat, he again worked on several canvases at once, without exception in the early morning while the trees and bushes were still shrouded in morning mist. In these pictures, shapes are almost entirely dissolved; the above-ground world blends seamlessly with its own image in the reflection on the surface of the water. In this way, Monet created harmonic color formations graded in fine nuances that are distinguished from complete abstractions of the pictorial object only by the hint of outlines and a horizon. Even so, the pictures remain "readable," and prove Monet's extraordinary capacity to generate spatial depth with few design features and depict complicated reflecting surfaces comprehensibly.

In the meantime, Monet revised his works ever more frequently and

Seine Backwater at Giverny, 1896
Oil on canvas
73 x 92 cm
Museum of Fine Arts, Boston

Unlike subjects in earlier series pictures, the Seine backwater changed continually as a subject. Whereas the first pictures were relatively object-based, later outlines and shapes dissolved in favor of pure color structure.

The Studio Boat, 1876
Oil on canvas
72 x 59.8 cm
Barnes Foundation, Merion

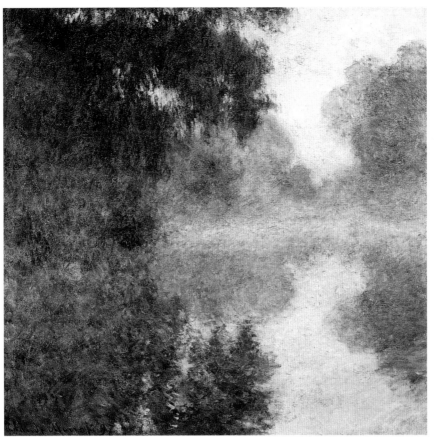

**Seine Backwater at
Giverny in a Mist**,
1897
Oil on canvas
89 x 92 cm
Musée Marmottan,
Paris

This series of pictures
is a transition from
the early to the late
series. While the first
ones are boring and
ineloquent as
individual pictures,
from here on the
individual pictures
hold their own and
give adequate
information about
the whole series.

From now on, Monet
quit the expressions
of concrete light-and-
shadow-relations.
Instead of this, he
transmitted the
impression of his
mood, stimulated by
a particular place, in
color. By this, he
created calm and self-
relaxed compositions
with a raising degree
of abstraction.

intensively in his studio in Giverny in order to attune individual pictures in a series more precisely to one another. In addition, he investigated and worked on the color effect of works in the light situation of a closed room, such as they would later be subjected to in a gallery, museum or private house. Although this procedure benefited the effect of the pictures, it did represent a certain formal break that is instructive for Monet's development and indeed that of Impressionist art as a whole: the spontaneous reproduction of a moment, the direct artistic processing of an "impression," previously so fundamental, had retreated to the background in favor of conscious manipulation and careful studio work.

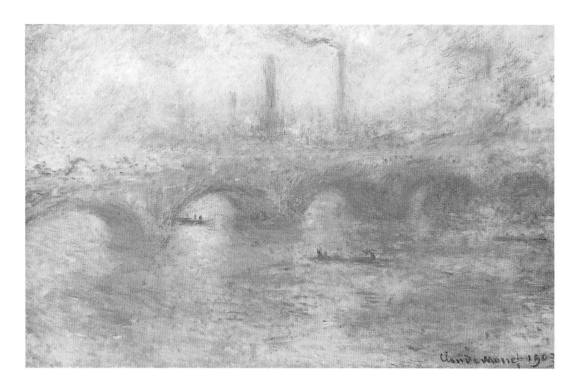

London

Monet had returned to London several times since his first stay in 1870/71 without the journeys perceptibly having an effect on his work. It was only in autumn 1899 that he felt a more positive urge. He and his wife Alice occupied a room in the Savoy Hotel that enjoyed a fairy-tale view of the Thames. It looked upstream towards Charing Cross Bridge, and downstream towards Waterloo Bridge and the Houses of Parliament. Monet began working on three series at once, each based on one of the Thames bridges or Parliament. Bad weather forced him to break off his work and

return to France. He only resumed work in 1900 and 1901 during further stays in London, completing them finally in his studio in Giverny in 1904.

Eighty five works were produced, of which Durand-Ruel showed 35 in a sale exhibition that would turn out to be Monet's greatest success to date. Collectors from the USA, Britain, and increasingly France as well purchased his pictures for extremely high prices, and the more emphasis the painter placed on producing series of pictures, the less value the public seemed to place on pictorial content. They

Waterloo Bridge, Mist, 1901–1903
Oil on canvas
65.3 x 101 cm
Hermitage, St. Petersburg

Monet's subject here was not modern city life but, as in Rouen, the atmospheric appearance of architecture. The bridge is reduced to a color phenomenon, suggested by a few compositional elements.

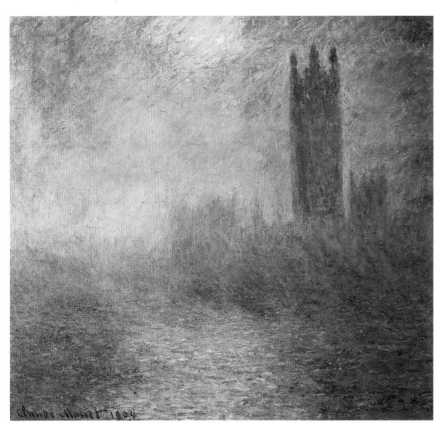

Houses of Parliament, the Sun Breaks Through the Mist, 1904
Oil on canvas
81 x 92 cm
Musée d'Orsay, Paris

In London, Monet stuck to a precisely planned schedule: in the mornings he painted the Thames bridges from his hotel window, in the late afternoon he went to the terrace of St. Thomas's Hospital, where he got an excellent view of the Houses of Parliament in the evening sun. The particular interplay of light effects and subject matter is intensified here by Monet almost to pathos: the dramatic color and brightness contrasts seem symbolically charged.

J. M. W. Turner
Houses of Parliament on Fire,
(detail) ca. 1835
Oil on canvas
92 x 123 cm
Museum of Art, Philadelphia

Although Monet denied being directly influenced by Turner, the unbridled colors of the London series show many similarities with Turner's representations of shimmering light phenomena.

were no longer buying a particular picture, they were buying a Monet.

However, the success of his work did not tempt the painter into a frenzy of mass production. He maintained strict quality expectations of himself and now hesitated ever longer to declare his works finished and show them to the public.

Venice

At the end of September 1908, Claude and Alice went to Venice for two months. They first took up residence at the Palazzo Barbaro, later moving to the Grand Hotel Britannia on the north side of the Grand Canal. During trips round the city, Monet was always on the lookout for suitable spots to set up his easel, because, as in London, he wanted to work on several series of pictures. He decided on eight different views, including the Doge's palace, which he painted from the terrace of San Giorgio, and the Grand Canal, which offered interesting water reflections.

In contrast to traditional *vedute*, Monet was not aiming at detailed reproductions of splendid palazzi. He more often showed them in sections in order to illustrate his actual concern, which was the contrast of masonry and water, the solid and the changeable. Monet's Venice series show the city almost "de-pictured," its architecture enshrouded in a veil of color. With all the pictorial elements having equal intensity of color, the effect of spatial depth is suspended, so that a flat pictorial impression results. Although they remain object-based, the pictures primarily display not recognizable objects but, as in the London works, the pre-eminence of abstract color harmonies.

Monet worked alternately on each subject for two hours, whenever the weather and his flagging eyesight allowed. Twenty-nine pictures of his

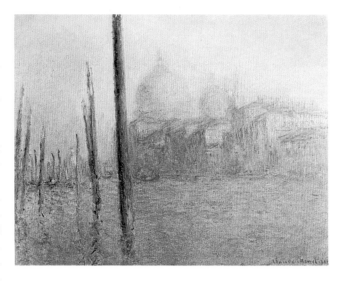

The Grand Canal in Venice, 1908
Oil on canvas
73 x 92 cm
Palace of the Legion of Honor, San Francisco

This is probably the most systematic Venice series. Monet always chose

approximately identical canvas formats, and always rendered the subject in exactly the same section with the posts used for mooring gondolas.

Below:
The Palazzo da Mulda, 1908
Oil on canvas
62 x 81 cm
National Gallery of Art, Washington

A balanced, flat color harmony whose subject matter is of no importance.

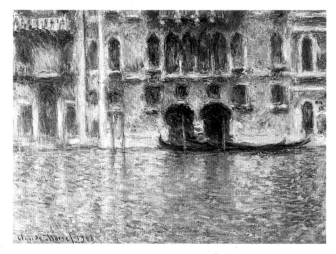

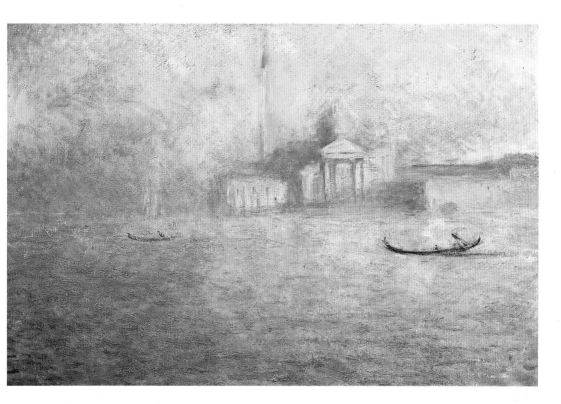

San Giorgio Maggiore, 1908
Oil on canvas
60 x 80 cm
National Museum of Wales, Cardiff

Ironically, due to the topographical and weather conditions in Venice, this impression dissolved in pure color is at the same time an almost naturalistic portrayal.

Claude and Alice in St. Mark's Square, 1908
Anonymous photo

series from Venice were not exhibited in Paris until 1912, because Alice fell ill with leukemia and Claude put his work aside to be able to look after her. But his longtime partner would not recover, and she died on May 19, 1911. Her loss plunged Monet into a profound personal crisis, during which he worked very little. For a time, he even thought of renouncing painting: "I find painting disgusting," he wrote to his step-daughter Blanche. "I am going to put down my brush and paints for ever …"

The Water Lilies 1909–1926

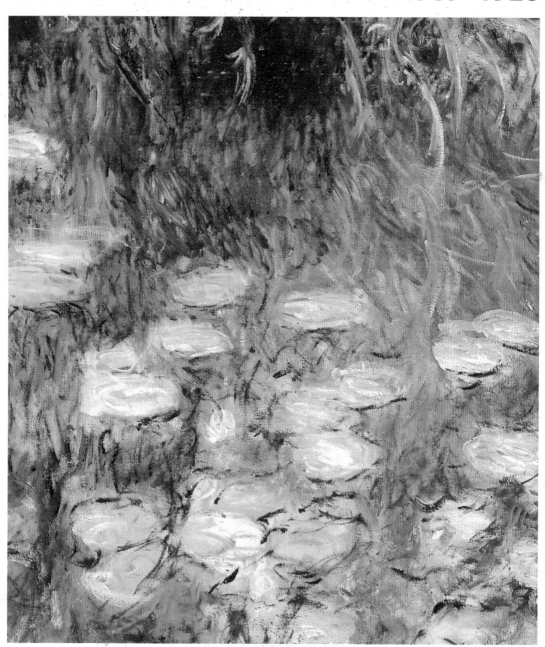

Having bought the estate in Giverny, Monet began to redesign the garden. The artfully arranged plants and his new water-lily pond inspired the painter to create numerous garden pictures. Appealing partly because of their rarity but also because of their colors, the water lilies soon became his principal subject matter.

When Alice died in May 1911, Monet was plunged into a profound personal and creative crisis. The artist in him was buoyed by words from long-standing friend and later French prime minister Georges Clemenceau, who encouraged him to turn a long-cherished desire into reality. Shortly before the outbreak of the First World War, Monet began his "Grandes Décorations," giant water-lily pictures that were to be installed in public rooms, to create a place for meditation. Because of his eye complaint and constant revisions, the project could not be shown until May 1927, after Monet's death, in the Orangery at the Tuileries.

Assassin of Sarajevo arrested, 1914

Monet in 1924

1912 Titanic disaster. Vassily Kandinsky paints abstract improvisations.

1913 Blauer Reiter group of artists founded. Malevich paints the Black Square.

1914 World War I breaks out (until 1918), following the assassination of the Austrian crown prince in Sarajevo.

1917 October Revolution in Russia overthrows the Tsars. Death of Rodin.

1911 Death of Alice. Monet's personal crisis begins.

1912 Exhibitions in Paris, Vienna, Frankfurt, and Boston.

1913 Travels to Switzerland with his son Michel. Three tapestries made from water-lily pictures.

1914 Death of his oldest son, Jean. Monet begins large-scale pictures of water-lilies as wall decoration.

1915 Has a new studio built for the water-lily decorations.

1918 His eye complaint gets worse. He can distinguish colors only by the labels on the paint tubes. Completes eight water-lily decorations.

1922 Death of Durand-Ruel.

1923 Cataract operated on.

1926 Dies in Giverny on December 5, aged 86.

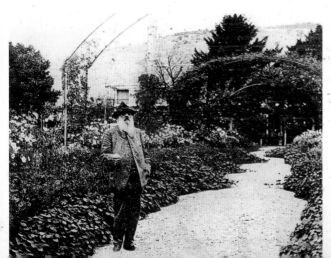

Monet in the northern part of his garden in Giverny, photo ca. 1925.

Opposite:
Water Lilies: Morning (left side), 1916–26
Oil on canvas
200 x 212.5 cm
Orangerie des Tuileries, Paris

The Water Lilies (1909–1926) **79**

Extending the Garden

At the end of 1890, seven years after his arrival in Giverny, Monet was given the opportunity to buy his estate. As the design of his garden had become Monet's second great passion beside painting, he hardly hesitated, and began at once to redesign the place. Even today, the way the plants are arranged still betrays the practiced painter's eye; flowers and shrubs were scattered far and wide in specific color combinations that set each other off to advantage so that, viewed from a distance as with Monet's Impressionist paintings, they dissolve into shimmering patches of color to make a kind of flower carpet.

In 1893, he bought a further piece of land on the south side of his property stretching between the railway and the small Ru river. Here, Monet constructed a water-lily pond with a

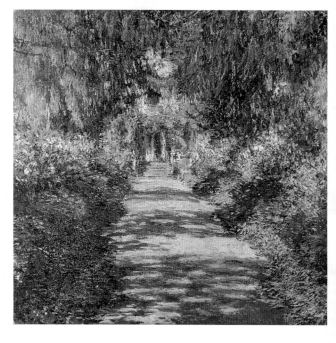

Monet's Garden,
1902
Oil on canvas
89 x 92 cm
Österreichische
Galerie, Vienna

wooden bridge as was traditional in Japanese garden culture. This acted as an Asiatic-style counterpart to his more traditional European flower garden. Following further extensions in 1901 and the diversion of the Ru, the water garden covered a total area of 1,000 square meters, and had acquired its present day appearance. South of the screen of willows round the pond there was now a small artificial island with bamboo bushes, cherry trees, and gingko trees.

From 1895, Monet began to paint his water garden. Changing constantly as new plants were added and existing ones waxed luxuriant, this inspired him to numerous views and series totaling more than 250 paintings that integrate the garden into his oeuvre as total art.

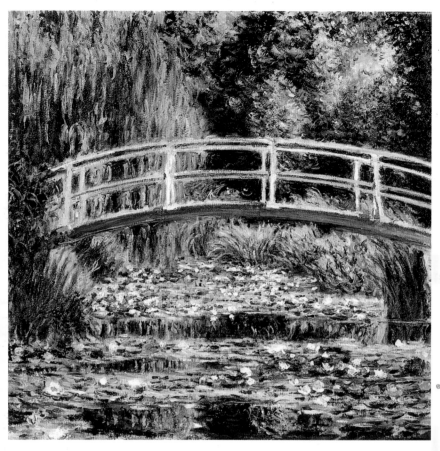

The Lily Pond, 1899
Oil on Canvas,
89 x 92 cm
Pushkin Museum,
Moscow

From July 1899, Monet painted the Japanese bridge, the construction of which followed years of enthusiasm for Japanese culture. (Numerous woodcuts adorning Monet's house in Giverny also bear witness to this.) In this picture, Monet moved the bridge further into the upper half of the picture than in most of the others of this twelve-work series. The viewer's gaze thus dwells more readily on the surface of the water, which would soon become an obsession with the artist.

In the meantime, he still showed the splendid vegetation on the banks of his pond, as if he wanted to show first the real nature that would later only feature in the reflection on the water.

The water lilies lie on the water like a carpet. In a masterly management of perspective, Monet paints the elliptical plants receding into the background.

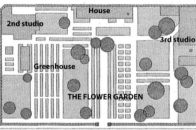

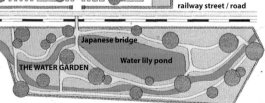

Monet's garden in Giverny after the extensions

Opposite:
Monet in front of his house in Giverny
Photo ca. 1920

A Passion for Water-lilies

It took me some time to understand my water-lilies ... I had planted them purely for pleasure; I put them in without thinking of painting them. A landscape doesn't get to you in a day. And then suddenly it dawned on me how wonderful my pond was, and I reached for my palette.

Claude Monet

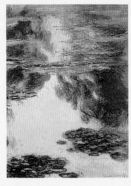

The move to Giverny signaled the start of Monet's gradual retreat into the seclusion of his garden. From the first water-lily pictures, which Monet painted from 1897, to the time he resumed painting in 1914, the continuity of his work was constantly interrupted by travels and personal misfortunes. Yet the series done in 1897 already contains the innovative features that would be taken up and further developed by the next generation of artists. For example, the horizon, which was still visible in his Seine pictures, is now mostly ousted from the picture altogether. All that remains is the surface of the water, in which clouds and plants are reflected.

With the stable element of the picture thus removed, the viewer's eye is left free to find its way around without instruction, perspective or guidelines. The bright sky area now becomes out of necessity the bottom half of the picture and the darker, optically heavier area of the bank the upper half. Thus Monet simply turns the traditional visual weighting upside down. The result is that the illusionary can no long be completely

Water-lilies, 1907
Oil on canvas
100 x 73 cm
Musée Marmottan, Paris

distinguished from the real, particularly when, from 1905, focusing on still smaller areas of reality, he left out the bank altogether. The real world is now represented only by water lilies and their elliptical leaves, mostly dabbed or sketched in, but from 1914 usually appearing in rounded patches of color in sweeping contours.

This development, rendering visible the transition from the real to the unreal by means of landscapes as pictures of a fluid (that is reflected) world, culminates in the great water-lily decorations on which Monet worked from 1914 to his death. Here he created a subjective, dream-like sunken space with softly graduated, quasi-filtered color tones, whose intimacy

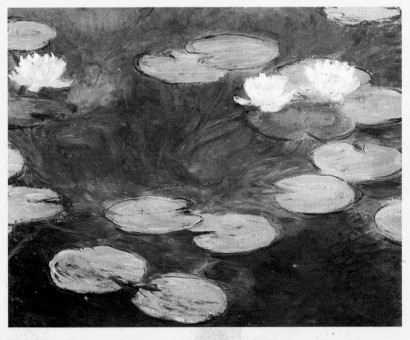

Water lilies, 1907
Oil on canvas
90 x 105 cm
Galleria d'Arte Moderna, Rome

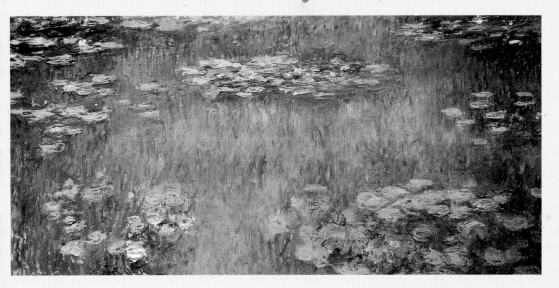

and solitude the viewer can experience directly by dissolving the distance from "eye to canvas" and being surrounded by this watery landscape. This is because, after Monet's death, the canvases – some of them eight meters wide – with their life-size water-lilies were installed in oval rooms. The viewer thus no longer finds himself in front of the pictures but in the middle of an installation, surrounded by the *enveloppe*, the atmospheric envelope, the visual concept Monet had been passionately working on since his haystack series.

The Lily Pond, Green Reflections, ca. 1920
Oil on canvas
200 x 425 cm
Stiftung Sammlung E.G. Bührle, Zurich

The Lily Pond
Photo ca. 1921

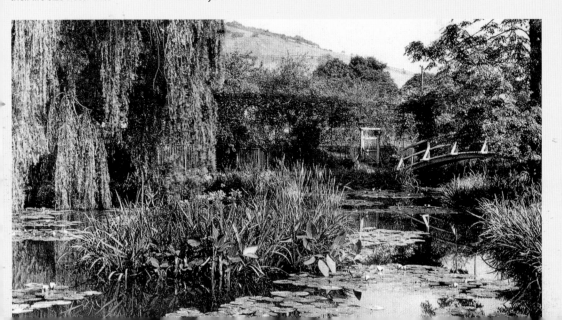

at a time when many people were losing their lives on the battlefields. Monet therefore decided to take part in events in his own way and, at the end of the war, present the series to the French state as a gift.

He never got that far. Until the day of his death on December 5, 1926 the almost blind artist was working obsessively on 22 pictures in total, and would not be parted from even one. On May 17, 1927, the water-lily decorations were first shown in the Orangery of the Tuileries, near the Louvre and Seine in the heart of Paris, which had been specially rebuilt for the occasion. They were Monet's legacy.

The Legacy in the Orangery

Monet was profoundly stricken, both personally and artistically, by Alice's death in May 1911, a blow aggravated by the premature death of his eldest son Jean in February 1914. In the end, it was his long-standing friend Georges Clemenceau who encouraged him to tackle his ambitious project for the "Grandes Décorations." Monet planned to paint huge canvases of water-lilies up to eight meters wide, which would be installed in a suitable room to allow undisturbed meditation. He began work in June 1914, shortly before the outbreak of the First World War, but was soon assailed by doubts as to whether painting water-lilies was defensible

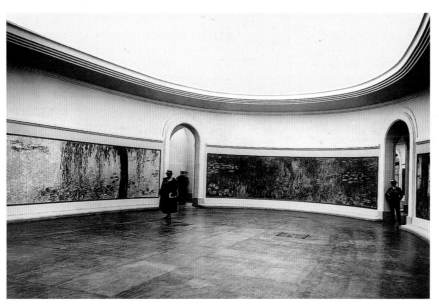

Monet's *Nymphéas* wall decorations in the Orangerie, Paris
Photo 1930

Monet's lilies were installed in the oval, windowless rooms of the Orangerie, an annex of the Tuileries. In their fusion to a place intended for contemplation, they were not just decoration but enhanced to an art that can be experienced emotionally.

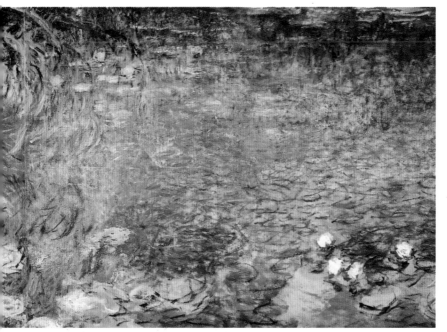

Water lilies: Morning (left part), 1916–1926
Oil on canvas
200 x 212.5 cm
Musée de l'Orangerie (First Room), Paris

In Japanese terms, a water-lily pond symbolizes the reflection of the human soul. Although some critics saw only superficial decoration in Monet's water lilies, they nevertheless show the "inner nature" of the painter uniting with the "external".

Monet and the Consequences

Water Lilies, ca. 1918
Oil on canvas
100 x 300 cm
Musée Marmottan,
Paris

Vassily Kandinsky
**Impression III (The
Concert)**, 1911
Oil on canvas
78.5 x 100.5 cm
Städtische Galerie
Lehnbachhaus,
Munich

Up until after the Second World War, Monet was stuck with the image of an artist who had reached his own limits trying to capture momentary impressions on canvas, and in the end had painted only flat, decorative, and rather prosaic water-lilies. He was of course celebrated and admired as a master of Impressionism, but not as a forerunner of modern art.

His rehabilitation did not begin until the mid-1940s, a Monet revival that can be directly attributed to the young artists of Abstract Expressionism in the USA. Monet's *Haystack* series of 1891 had already been a first anticipation of his late work and influence on many later artists, in that it demoted subject matter in favor of autonomy of color.

Around the turn of the century, the notion was developed by Post-Impressionism and the Symbolists, and after that mainly by Fauvistes, such as Matisse and Derain, until finally the early abstract artists Kandinksy and in Russia Malevich made color the determinative pictorial element, detaching it from its association with form.

The first rigorous, scholarly examination of Monet's late work came not from Paris, but from New York, after artists such as Clyfford Still and Jackson Pollock had shown their now "classic" works as of 1946. Subsequent investigations of Monet's influence on post-war American art inspired many exhibitions of the water-lily series outside France. A Monet revival in Paris had to wait until 1956/57, when gallery owner Katia Granoff exhibited Monet's late work. Now, Monet stands alongside Cézanne and Van Gogh as a forefather of modern painting, whose art linked the avantgarde of the 19th century with the new artistic developments of the postwar period after 1945.

Jackson Pollock
Gothic, 1944
Oil on canvas
215.5 x 142.1 cm
Museum of Modern Art, New York

From the mid-1940s, the American painter Jackson Pollock painted pictures that followed on from Monet's late water-lilies of the 1920s, with Pollock using paint direct from the tube and producing an even spread of blobs, dots, and curving lines with the spatula. The result was a rhythmic network that no longer contains any individual forms.

Roy Lichtenstein
Haystack no. 6, Version 3, 1969
Color lithograph on paper
34.1 x 59.7 cm
National Gallery of Art, Washington

Using his typical painting technique and a pop-art approach, Lichtenstein did a "copy" of Monet's icon as a response to non-objective Abstract Expressionism.

Glossary

Abstract Expressionism Collective term for various non-objective styles of painting of the 1940s–1960s in which color, form, and painting technique are the only media for expression and meaning.

abstraction Disregarding naturalistic or depictional rendering to the point of completely dispensing with objective representation. From 1889, Monet's style became increasingly abstract as he sought to capture the pure light atmospherics enveloping – and thus apparently dissolving – the pictorial object.

Barbizon School A group of French artists (including Th. Rousseau, C Daubigny and J-F Millet) who took up open-air painting in the 1840s. The young Impressionists took their cue from the Barbizon School and organized similar painting sessions in Fontainebleau Forest, near Barbizon.

caricature (Italian *caricare*, "overloaded, exagerrated"). Closely defined, a portrait of a (usually public) figure where the typifying features are exaggerated to become satirical or humorous. Due to new mass production printing techniques in the 1830s, caricature became a popular form of illustration used in the press. Monet produced caricatures to finance his studies in Paris.

complementary colors Colors opposite each other in a color circle or triangle (blue-orange, red-green, yellow-violet), which when juxtaposed intensify their brilliance by their color contrast.

composition Formal structure of a picture based on visual organizational principles. The principles may include the relationship of color and form, symmetry/asymmetry, movement, rhythm etc.. Composition also includes the arrangement of pictorial planes, that is the way foreground, center ground, and background interrelate.

contour Outline of a shape produced by a line or color contrast.

enveloppe [Fr. "envelope"] Monet's term to describe all atmospheric, spatial, and temporal influences that characterize a subjective, momentary impression.

history painting (Grand Manner) The representation of persons or events of historical importance, or subjects from legends, the Bible or classical mythology, depicted in a naturalistic or idealized style. Until the late nineteenth century, history painting was reckoned the highest genre of art, followed by portraits and the "inferior" genres of landscapes, still lifes, and genre paintings.

Impressionism Style of painting developed in France around 1870 that focused on capturing objects in their momentary dependence on light. Characterized by a fragmented painting technique, bright coloration, and often apparently random choice of pictorial frames. Preferred subjects were landscapes or scenes of urban life. The name came from Monet's painting *Impression, Sunrise* exhibited in 1874 at the first independent group exhibition. After the exhibition, critics used the term "Impressionist" perjoratively for the whole group, which included Monet, Manet, Cézanne, and Renoir among others.

landscape painting Paintings with geographical landscapes as subject matter. Although initially landscape was an accessory for filling in background (for example of a religious painting), by the end of the sixteenth century it had developed into an independent genre. The seventeenth century created the "ideal" (for example Claude Lorrain's transfigured landscapes) and the "heroic" landscape (Poussin's highly symbol-charged landscapes). Landscape painting reached its apogee in the Dutch baroque, and was rediscovered in the nineteenth century with the emergence of open-air (*plein air*) painting.

motif A pattern, visual idea or shape that can be reused within a painting in different ways, or in other paintings. Artists borrow motifs from each other. Sometimes the term can also mean the dominant idea in a painting, but this use is less common.

mythology Favorite subject matter of art since antiquity. Rediscovered in the Renaissance, mythology became an important source for many pictorial topics in western art. The Impressionists discarded such literary and historic subject matter entirely in favor of nature or subjects where their personal, on-the-spot perception was involved.

naturalism Style of the second half of the nineteenth century that strove to reproduce the external appearance of an object accurately. Also a general artistic concept.

oeuvre The total output of an artist. In his 60-year career, Monet did over 2,000 paintings, including about 300 water-lily paintings.

oil painting Paint medium in which the paint pigments (pulverized colors) are bound with oil. Oil paint is malleable, dries slowly, and can be easily worked into other oil paints. Oil painting emerged in the fifteenth century, since when it has been the dominant medium of painting. From the 1840s,

oil paint became available in transportable tubes, which made painting outside easier. Around the same time, synthetic pigments were developed. These were more brilliant and cheaper than traditional paints, but initially less permanent. As the Impressionists preferred permanent colors (in contrast to Van Gogh), they were very circumspect in the new paints they used.

open-air painting (Fr. *plein air*) Painting done in the open, i. e. direct from nature, rather than in the studio as in academic painting. Open-air painting first became important around 1800 with English painters Constable and Turner. In France, plein-air painting was rediscovered by the Barbizon School in the 1840s and taken up as a principle by the Impressionists from the 1870s. However, although Monet and his circle did at first indeed paint direct from nature, they later increasingly completed their paintings in the studio, sometimes effecting major revisions.

palette Painter's board on which paints are put out and mixed. In a figurative sense, it refers to the range of colors used by an artist.

pastose Term for a method of applying paint with a spatula or in thick brushstrokes so as to obtain

a chunky three-dimensional paint effect.

paysage intime (Fr. 'intimate landscape') A painting showing a simple but very atmospheric slice of nature. Characteristic of the Barbizon School.

perspective (Lat. *perspicere*, "to see through") Representation of objects, people, and spaces on a pictorial surface, as a result of which an impression of spatial depth is created by graphic and painterly means. Linear perspective was developed scientifically in the Renaissance for both painting and relief sculpture. Objects and people become smaller proportionally to the distance. Another way of creating the effect of depth in a picture is color or aerial perspective, where the objects represented lose intensity with distance and become bluish. Monet was not interested in accurate perspective constructions as he was not interested in naturalistic portrayal. His pictures were therefore sometimes criticized as flat.

plein-air painting See open-air painting

portrait Representation of a person in a painting. Types of portrait include self-portraits, single portraits, double portraits, and group portraits.

realism Broadly defined, a faithful visual representation. More

specifically, a description for a style of the second half of the nineteenth century that focused on everyday reality and work. As a young painter in the 1860s when he was painting in Fontainebleau Forest, Monet modeled himself on French realists such as Gustave Courbet.

replica Repetition of a work by the same artist (or studio). Monet did replicas of *Camille in the Green Dress* (1866) and the *Villas in Bordighera* (1884).

Romanticism Early nineteenth century style that elevated feeling to the supreme criterion. Mainly noted for moody landscapes and scenes based on medieval legends and history.

Salon Regular state-supervised presentation of new paintings initially instituted by Louis XIV in the Salon Carrée. In the nineteenth century, acceptance by the Salon depended on the vote of a conservative jury.

still life Genre of painting in which lifeless things such as fruit, dead animals, flowers or everyday objects are depicted. Monet painted occasional still lifes because, as commissioned works, they initially earned him more money than landscapes.

studio painting Paintings done in the studio from sketches or preliminary

drawings rather than direct from nature in the open air. Concept first explicitly formulated in the nineteenth century after open-air painting developed. Before that, the term was unnecessary, as all painting was done exclusively in the studio.

study Preparatory drawing for a work of art. Executed in various techniques, the degree of finishedness ranges from rapid sketches of physical attitudes or other compositional components to detailed artistic drawings.

vanishing point See perspective.

veduta Accurate drawing of a city or landscape.

watercolor Water-soluble colors that dry transparent, that is they do not cover what is underneath, and are therefore delicate and easy to work with.

Index

Picture Credits

© 2005 KÖNEMANN*, an imprint of Tandem Verlag GmbH, Königswinter

Editor: Peter Delius
Series concept: Ludwig Könemann
Art director: Peter Feierabend
Layout: Delius Producing, Berlin
Picture research: Jens Tewes, Florence Baret

Original title: Claude Monet. Leben und Werk
ISBN 3-8331-1072-4 (original German edition)

© 2005 for English edition: KÖNEMANN*, an imprint of Tandem Verlag GmbH, Königswinter

Translation from German: Paul Aston in association with Goodfellow & Egan
Editing: Susan James in association with Goodfellow & Egan
Typesetting: Goodfellow & Egan
Project management: Jackie Dobbyne for Goodfellow & Egan Publishing Management, Cambridge, UK
Project coordination: Nadja Bremse

*KÖNEMANN is a registered trademark of Tandem Verlag GmbH

Printed in Italy

ISBN 3-8331-1467-3

10 9 8 7 6 5 4 3 2
X IX VIII VII VI V IV III II I